BROCHURE DESIGN THAT WORKS

Secrets for Successful Brochure Design

DATE DUE

APR 0 6 2004		
APR 2 1 2004		
APR 2 0 2004		
NOV 2 4 2004		
NOV 2 4 2004		
FEB 2 6 2006		
FEB 2 8 2006		
APR 2 0 2006		
APR 2 1 2006		
MAY 3 0 2006	MAY 3 0 2006	
SEP 2 1 2006	SEP 1 8 2006	
OCT 0 2 2006	SEP 1 8 2006	
JUN 2 4 2011	JUN 2 5 2011	

ROCKPORT

BROCHURE DESIGN THAT WORKS

Secrets for Successful Brochure Design

GLOUCESTER MASSACHUSETTS

ROCKPORT
PUBLISHERS

Lisa L. Cyr

First published in the United States of America by
Rockport Publishers, Inc.
33 Commercial Street
Gloucester, Massachusetts 01930-5089
Telephone: (978) 282-9590
Fax: (978) 283-2742
www.rockpub.com

Library of Congress Cataloging-in-Publication Data

Cyr, Lisa L.
 Brochure design that works : secrets for
successful brochure design/Lisa L. Cyr.
 p. cm.
 ISBN 1-56496-912-6
 1. Pamphlets—Design. 2. Graphic design
(Typography) I. Title.
Z246.C97 2002
686.2'252—dc21 2002004537

10 9 8 7 6 5 4 3 2 1

Design: Leeann Leftwich Zajas

Cover Image: *The Voices and Visions of Freedom*
designed by Summa

Photography: Kevin Thomas Photography &
 Bobbie Bush Photography www.bobbiebush.com

Copyeditor: Pamela Hunt

Proofreader: Stacey Ann Follin

Printed in Singapore

I would like to give special thanks to all of the designers who took the time to participate in this endeavor. Their talents, words of wisdom, and insight helped to make this book a reality. Much gratitude to my magazine editors at *Communication Arts*, *Step-by-Step Graphics*, *Applied Arts*, and *HOW* for their excellent recommendations of talent, and to Kristin Ellison at Rockport for her assistance and guidance. I would also like to thank my husband, Christopher, and my daughter, Michaela, for their patience and loving support. God bless America and its friends throughout the world!

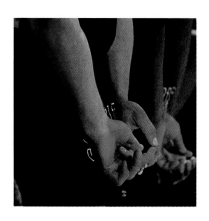

contents

NIGHT of the
JUMP
motocross freestyle world...
powered by Air-Team Berlin

change is good

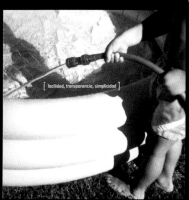

guaranteed robust bandwidth
home broadband
integrated wired and wireless
Ethernet backbone
new wires 100Mbps network
Clear demarcation point

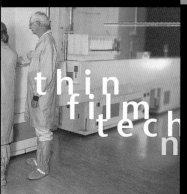

thin
film
tech
n

facilidad, transparencia, simplicidad

phoria deadline
burn out
anguish panic

Hannah goes where her *spirit* moves her,
unfettered by time or space or tradition

introduction

Riding the Wave

In the highly competitive global market of the twenty-first century, companies are looking to create distinction and strengthen their brand more than ever. To stay in touch with the needs of their clients, designers are adopting a more strategic role. "I think that design in general is moving away from a decorative execution to cleaner, clearer, and more simple message-driven design," remarks art director Lisa Cerveny of Hornall Anderson Design Works. "On all levels, designers are being asked to participate with the client more strategically, rather than as a decorator." Strategy, communication, and content are taking the lead while design plays a supporting role. "Graphic design and advertising are merging at certain points," offers Bryan Clark of Lewis Moberly. "There is a shift of emphasis on strategic thinking, and the messaging has become more streamlined and efficient as a result." Ron Miriello of Miriello Grafico agrees, "There is a practicality that is being put back into the work. There is no more design for design's sake."

This new focus on strategy has also affected the way brochures have been conceptualized and produced. A trend towards an editorial sensibility in brochures is evident. No longer do product or service brochures resemble mere catalogs. Designers are presenting companies in much more inventive ways. Brochures are becoming more storytelling in nature—captivating and entertaining the audience instead of the hard-core, somewhat cliché, sales approach of years past. "There is no room for hype," reminds Greg Samata of SamataMason. "You have to be

clear and forthright, delivering a message that not only you believe in, but that they [the audience] will believe in." This new editorial vision has also moved into investor relations and corporate communications. The best annual reports and corporate brochures put a memorable and human face on a company to make an emotional connection with their audience. Companies are starting to realize a brochure's brand-building potential and have allocated resources toward making their communications interesting and engaging. "In Europe, especially in Germany, more and more companies are investing themselves in graphic design—giving it more chances to be different and non-traditional," adds Lars Harmsen of Starshot.

Designers are not only presenting and promoting their clients differently, they are also promoting themselves with a more strategic and content-driven focus. Self-promotions have changed drastically, from a typical portfolio presentation to something that is more inventive. Designers are showing prospective clients what they can do in a more thought-provoking way. They are creating promotional pieces with perceived value—something that a client would want to hold onto and use. Books, calendars, and lots of collaborative endeavors are being explored.

Today's brochure is less about what a company wants to sell and more about engaging the audience to participate in the overall messaging. "Creating a piece that will be important to the audience is key. People don't want to see pretty pictures and self-effacing copy," details Rik Klingle of Thumbnail Creative Group. "You need to tell your audience something that they want to hear. You need to involve them in some way." To be engaging, designers have experimented with alternative formats and bindery that not only create distinction but also add an element of interaction. "Materials are being used unconventionally, and the architecture is evolving," notes Klingle. "Designers are taking a lot more time to study how someone will read and use what they produce." They are experimenting with brochures of various sizes and shapes, from tiny flipbooks to multipiece assemblages and everything in between.

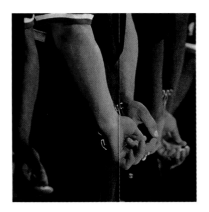 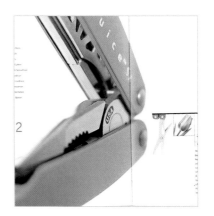 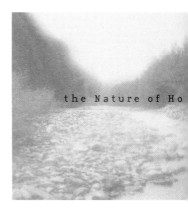

the Nature of Ho

Nothing is considered standard anymore. Innovations in printing have created an increase in the quality and a decrease in the quantity of brochures being produced. Stochastic printing and direct-to-plate processes have improved quality tremendously, while on-demand printing has allowed companies to cost-effectively decrease their print runs to well-targeted quantities.

Technological advances have also put a greater pressure on print to perform. "Print has to justify itself more than it used to, because companies have many more options when it comes to distributing their message," states Miriello. "Print has a more focused job than it ever did before." To survive, print has to play up its assets, its ability to provide a three-dimensional and tactile experience. "These days, people are looking for an emotional connection. They want to feel something," admits Katha Dalton of Hornall Anderson Design Works. "Because of the web, I believe print has been elevated to a higher level as a fine craft."

Because of the events of September 11 and the overall decline in the global economy, design has to work harder than ever before. "The market is changing, and there is a huge shift in the economic climate," says Samata. "Certain industries are more in favor than others, and companies are confused and not really sure what to do." Resources are being tightly utilized, and companies are trying to get the most impact for their money. "September 11 has had a direct impact on how we work and design because of the economy and budget pressures that exist. The tone and voice of the messaging is completely different," acknowledges Greg Salmela of Aegis Toronto. "Companies have to speak to reduced revenues and a shrinking market, and designers are just coming to grips with the changes in the world and in the mood of our clients. It's going to be interesting to see what happens."

the greater toronto airports authority

CLIENT:
The Greater Toronto Airports Authority (GTAA) is a privately owned company that manages public resources.

FIRM:
Aegis Toronto

CREATIVE DIRECTOR:
Michael Dila

ART DIRECTOR:
Greg Salmela

DESIGNER:
Moses Wong

PHOTOGRAPHER:
Various architectural and stock photography

ABOVE: Each section, alternating from orange to blue, begins with an aeronautical theme, which serves to express parallel meanings. A single key word introduces the theme and is followed by an associated image printed on translucent paper—Neenah UV/Ultra II in radiant white.

Structure within Structure

The GTAA's long-awaited international airport is already under construction. The challenge for the design team at Aegis Toronto was how to develop an annual report that will instill importance, value, ownership, and pride in what is currently perceived as a massive, multibillion-dollar obstacle. "We didn't want people to focus on the trucks, concrete, and steel girders, but on this great thing that looms in Toronto's near future," says project manager Michael Dila. After visiting the airport and getting a feel for the environment, the design team developed several concepts that were critiqued internally before the final idea was presented to the client. "What is

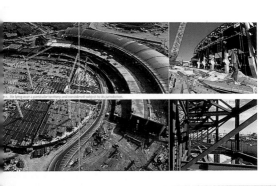

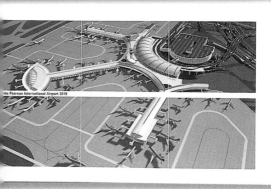

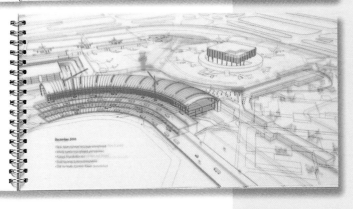

OPPOSITE: The aeronautical theme continues with a series of pictures that helps to visually support the message. The key word *lift* refers to the lifting of a structure from the ground as well as the lifting of a plane. On the opposite page, an orange text block poetically explains the conceptual connection between the key word, images, and message.

TOP AND BOTTOM: To convey the project's metamorphosis over time, translucent overlays, all relating to one an-other, are used to show a quarter-by-quarter view of the construction's progress. Using a CAD system, the artwork is created through collaboration between the design team and the airport's architectural firm.

remarkable about the project is that the new airport was being constructed over the existing airport, which continues to run largely unaffected," comments art director Greg Salmela. "I immediately had a picture in my mind of a translucent structure over a solid structure, which later became the cover. In the interior layout, I wanted to continue the same vision, where the images and the copy had to be less tactical and more emotive."

Even though the design team thought this was a dream project to work on, there were several technical challenges along the way. They struggled with how to support and fasten the paper report within the polyurethane cover so that it laid flat and did not droop. "We went through a whole string of tests to find a way of attaching the cover so it would support its own weight and withstand wear and tear," shares Salmela. "We ended up doubling over 100-lb. Potlatch McCoy matte finish cover stock and fastening it with rivets to the cover." It's critical that the piece remains sound because the physical structure of the report is integral to the overall message. The impressive annual report is printed in eight colors.

What Works

Through its size, shape, structure, and layout, the annual report conveys a sense of scope, scale, wonder, and achievement. The juxtaposition of the architectural linework, imagery, and text propels the narrative from front to back. A project once seen as an obstacle has now become an inspiration for the community, the city, and the country.

clemenger communications limited

CLIENT:
Clemenger Communications Limited is an advertising and communications group that offers integrated services across a number of disciplines.

FIRM:
Emery Vincent Design

ART DIRECTOR/DESIGNER:
Emery Vincent Design

MANAGING DIRECTOR:
Penny Bowring

PHOTOGRAPHER:
Existing client photography

COPYWRITERS:
Emery Vincent Design and Clemenger Communications Limited

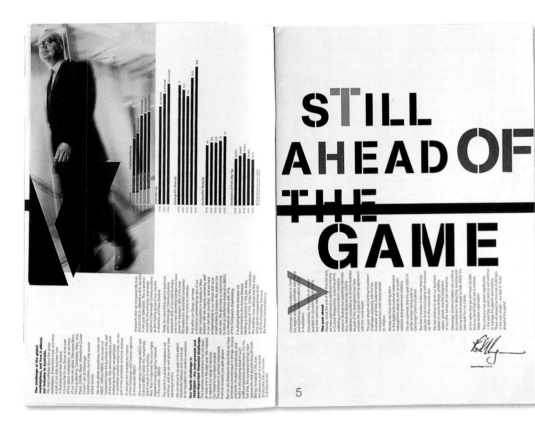

ABOVE AND OPPOSITE: Using easily readable snippets of information throughout, the annual report has an editorial flair and immediacy that is necessary in the fast-paced communications industry. The bold and edgy use of type and graphics helps to position the group as highly creative and innovative.

Creative Unity

The task for the design team at Emery Vincent Design was to create an annual report that positioned Clemenger Communications Limited as a highly creative group of integrated marketing companies in Australia and New Zealand. The annual report's main objective was to convey the breadth, range, and success of each company under the Clemenger Communications Limited umbrella. "The group comprises a diverse range of businesses, each of which has its own identity as a market leader in the field," shares managing director Penny Bowring. "The aim of the group is to develop ideas through strategic think-ing and creativity and to become increasingly involved in all areas of persuasive communications." One of the biggest challenges for the design team was finding an effective format for presenting both the group as a whole and the individual businesses that constitute it.

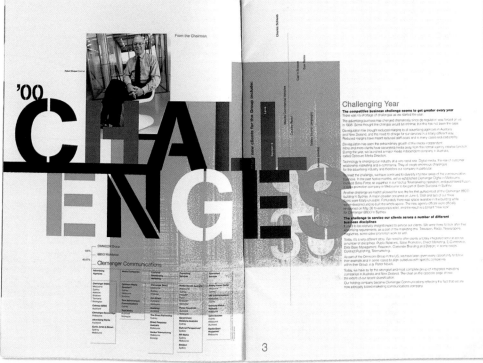

To express the creative energy, spirit, and diversity of the innovative group, the design team chose to use an untraditional format and layout. "We departed from the standard A4 size to a tabloid-size document, which was highly editorial in both content and layout," notes Bowring. "The tabloid-style document served as a news piece rather than as a conventional report. This approach enabled many businesses to communicate their achievements in a unified form." Throughout the annual report, the bold use of type and shape helped to communicate a contemporary, strong, and energetic feeling towards the group. The textural patterns, created using various tones made by a photocopier, were combined with type and shape in Adobe Photoshop. "The texture gives the impression that the type has been stamped using a hot metal letterpress," adds Bowring. "The juxtaposition of elements creates a dynamic tension in the design." The annual report was cost-effectively printed in two colors to meet the client's budget constraints.

What Works

The large format and unconventional layout help to communicate the group's creative energy and spirit, distinguishing Clemenger Communications Limited in the marketplace. "Historically, the document had been a very boring A4 brochure printed in one color with no design input. It was generally ignored by the owned companies and not used as part of their business pitches," claims Bowring. "The new design attracted their attention and has made them proud to use the report."

manpower inc.

CLIENT:
Manpower Inc. delivers staffing solutions to a diverse range of customers around the globe.

FIRM:
SamataMason

CREATIVE DIRECTOR:
Greg Samata

DESIGNER:
Beth May

PHOTOGRAPHER:
Sandro

COPYWRITER:
Tracy Shilobrit

bilingual call center agent

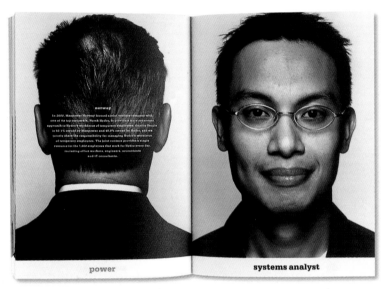

power

systems analyst

Diversity

"Manpower Inc. had a unique problem. They struggled with how to communicate the depth and range of their company," recalls creative director Greg Samata. "Most people think that they only have people who do clerical work. There are scientists, computer specialists, and genetic engineers that they also employ and lease to the world." The design team chose a simple but highly effective concept. "We wanted to relentlessly represent all of these jobs with a face of a person," notes Samata. "We wanted to show a diversity in cultures and in types of jobs. We wanted the reader to be overwhelmed by the sheer number of people and the job titles worldwide."

Throughout the entire annual report, several jobs are symbolically shown through the faces of a culturally diverse workforce. Twenty-nine models were chosen from a cast of hundreds. Both the front and back of the heads were tightly cropped and positioned against a blue background—Manpower Inc.'s corporate color. The sequencing of images was highly planned— considering the jobs, countries, and look of each model. "By the time you go through the piece, you have an understanding of the company, a depth of the people, and a global scope without saying one word. It does so much with so little," observes Samata. "I like the idea of solving a problem where the content of the message is driven by the experience of going through it. The best books have one simple message from cover to cover." The annual report is also used all over the world as a door opener representing the brand.

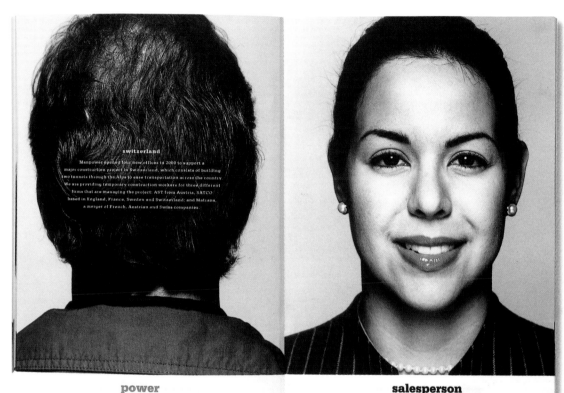

switzerland

Manpower opened four new offices in 2000 to support a major construction project in Switzerland, which consists of building two tunnels through the Alps to ease transportation across the country. We are providing temporary construction workers for three different firms that are managing the project: AST from Austria, SATCO based in England, France, Sweden and Switzerland; and Matians, a merger of French, Austrian and Swiss companies.

power

salesperson

LEFT AND OPPOSITE: **Each spread symbolically represents not only the range but also the depth of staffing solutions available through Manpower Inc. around the world.**

What Works

Because of its continuous focus on one clear and comprehensive message, the annual report was able to communicate Manpower Inc.'s diverse and global selection of staffing options. "From the moment we showed the president [of Manpower Inc.] the piece, he understood exactly how much mileage he could get out of this book," adds Samata.

herman miller

CLIENT:
Herman Miller, a contract
furniture manufacturer, is
introducing its latest innovation,
the Resolve System.

FIRM:
BBK Studio

CREATIVE DIRECTOR:
Steve Frykholm

DESIGNERS:
Yang Kim and Steve Frykholm

PHOTOGRAPHER:
Herman Miller archives

ILLUSTRATOR:
Jack Unruh

COPYWRITER:
Clark Malcolm

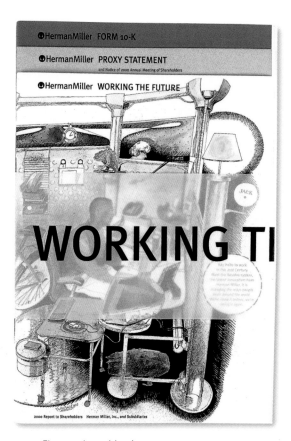

ABOVE: The annual report breaks
up into three sections—theme
book, proxy statement, and form
10-K. They are wrapped and held
together by a bellyband.

Personal and Friendly

"Every year we get together with the client to talk about
a theme for the annual report. This year's theme was
about the introduction of a new product line called
Resolve," says designer Yang Kim. "The product is very
unique in that it redefines and transforms the office
environment. The whole idea behind the line is that it
creates communities and areas of personalization. So,
with this annual report, we tried to give the piece a
human quality that is friendly and fun." Researching the
intricacies of the product line was crucial to ensure that
it would be portrayed appropriately. "We took a lot of
snapshots, looking at locations and making sure we had
the right product mix represented throughout the book,"
Kim details.

The design team chose illustration as their venue for
interpreting the new and innovative line, and the
whimsical handwork of illustrator Jack Unruh was the
perfect choice to convey the message. Within each
illustration, there are sidebars—concepts that Herman
Miller wanted to communicate to its audience about
how to improve work environments. In the midst of the
theme book, a gatefold illustration depicts the Resolve
product development team. "They are the main people
that helped launch the product," notes Kim. "It's sort of
a homage to the team." In addition to the report, BBK
Studio developed a booklet of "firsts"—Herman Miller
innovations over the past fifty years. The booklet was
also used as a stand-alone brochure. "It is a reminder
of the great things that Herman Miller has to offer, and
it ends with the new Resolve line," offers Kim. The
illustrated annual report breaks up into three sections
that are wrapped and held together by a bellyband.
The annual report also serves as a corporate overview
brochure for Herman Miller.

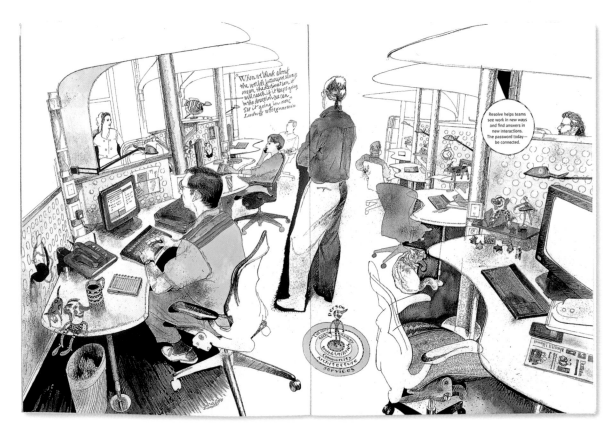

LEFT: In each spread, the Resolve line is illustrated in a warm, friendly, and inviting manner. In conjunction with the annual report, the "first" booklet highlights fifty years of innovative designs from Herman Miller. The booklet ends with the new Resolve line.

What Works

Distributed to shareholders and institutional investors, the illustrated annual report communicates the personal side of the high-tech product. "It was a hit with the sales force," notes Kim. "They essentially use it as a kind of capabilities piece with prospective clients."

dwl incorporated

CLIENT:
DWL Incorporated's enterprise customer management applications consolidate fragmented customer relationship management (CRM), back-office, and e-business systems into unified industry solutions.

FIRM:
DWL Incorporated
(in-house creative services)

ART DIRECTOR/DESIGNER:
Shawn Murenbeeld

ILLUSTRATOR:
Allen Crawford/Plankton Art Company

PHOTOGRAPHY:
Hill Peppard

COPYWRITER:
Leslie Ehm

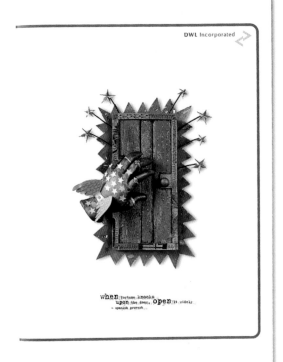

Creating Distinction

Because this was the first corporate brochure for the company, it was important that it stood out from the competition. "The main message of this piece was to convey that DWL is a different kind of company," claims in-house art director Shawn Murenbeeld. "In order to create distinction, I went antitechnology while the competition was going supertechnology." Throughout the brochure, a handmade quality prevails not only in the illustrations but also in the type. "That kind of attention to detail helps to convey that the company cares," adds Murenbeeld. "It also sets us apart from our competition, especially when we go to tradeshows."

Originally four ideas were developed, but one stood out above the rest. Insightful proverbs were used to introduce various key points. "When I get a job, I like to have a theme to pull everything together, and proverbs seemed to work," comments Murenbeeld. "The writer and I went through books and the Internet and got hundreds of them. We selected the ones that would most closely relate to what we were talking about in the

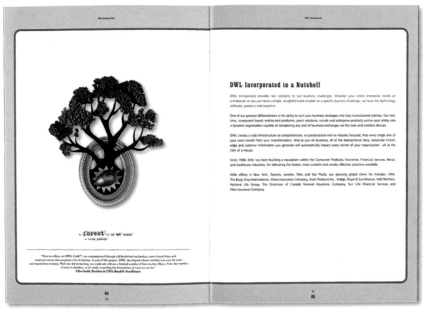

ABOVE LEFT: **DWL is able to make a mark in the industry by creating a corporate brochure that goes against the norm.**

LEFT: **In this spread, a nutshell or acorn is present in the illustration, headline, and proverb. They all work together to get the main point across. The color palette was pulled directly from the illustration and used as a border accent.**

brochure." Once the proverbs were chosen, the art director went in search of the appropriate illustrator. "I went through the *Alternative Pick* because they have the most interesting illustrators out there," says Murenbeeld. After reviewing the work of several artists, three-dimensional illustrator Allen Crawford was chosen to do the job. "I gave him the proverbs and let him go with it. I don't like to art direct that much," claims Murenbeeld. "I like to hire illustrators because they have a certain style, look, or idea that I do not have." Once the art came in, it was photographed. Each spread contains an illustration, a proverb, a headline, and some text that all work together to deliver the message. "Copy and image must work hand-in-hand to be successful," concludes Murenbeeld. "It's only when designers and copywriters work together that effective communication can be produced."

What Works

By moving away from creating a technical brochure—the typical form of communication in the industry—DWL was able to create distinction for their brand. With its illustrative presentation and astute attention to detail, the corporate brochure brings a personal face to a rather high-tech company. Targeted primarily to corporate CEOs, this brochure established DWL as a unique company in the marketplace. It had such positive reviews that the color scheme was later used to accent DWL's various products. "The piece has been very successful for us," shares Murenbeeld. "Overall, everybody liked it, including the salespeople."

ABOVE: Along with the corporate brochure, a smaller four-paneled tradeshow brochure was printed. It contains several of the major points from the larger 20-page brochure.

stroock & stroock & lavin llp

CLIENT:
Stroock & Stroock & Lavin LLP
is a 150-year-old full-service
law firm.

FIRM:
Cahan & Associates

CREATIVE DIRECTOR:
Bill Cahan

DESIGNER:
Michael Braley

COPYWRITERS:
Cahan & Associates,
Andi Benjamin, Anna Pinedo,
Jim Tanenbaum, Lewis Cole,
Jay Linder, Jim Ponichtera, and
Suzanne Young

PHOTOGRAPHERS:
Jock McDonald (stories),
Todd Hido, and various stock

ABOVE: The design team presents
the forward-thinking law firm
within two brochures, elegantly
housed inside a handsome pocket
folder. The use of black and white
is used as a metaphor for arguing
both sides of a point.

Legally Radical

Stroock & Stroock & Lavin LLP wanted to reposition themselves in the marketplace. "They were very different than any other law firm that we had ever worked with," comments creative director Bill Cahan. "They were truly free thinkers. Their ability to work outside the box and solve cases that other firms could not had never been expressed before in any of their promotional materials."

After analyzing the firm's current market position and the overall competitive landscape, the design team developed a two-part series that worked together to communicate the company's unique approach. "They needed a package that would express the philosophies of their firm—seeing more and doing more," adds Cahan. The white brochure, called *Business Review*, focused on seeing more—the ability to see opportunity when faced with obstacles. The black brochure, called *Stories Volume I*, focused on doing more—the ability to go beyond the conventional.

Primarily photo-driven, this set of brochures created distinction and a new identity for Stroock & Stroock & Lavin LLP, setting them apart from their competition. "Other law firm brochures that we looked at did not use a lot of photography and were pretty copy-intensive," notes designer Michael Braley. "With these brochures, I tried to use large photos as the primary messaging, a definite differentiator." The black brochure features a series of success stories about the innovative law firm and its relationship to its clients in various industries. "I liked the juxtaposition and scale of the people against the larger objects," admits Braley. "I tried to come up with the best possible combination of the two—looking for interesting backgrounds, textures, and colors." The white brochure, on the other hand, is more conceptually driven. The photos and headline copy immediately grab the reader's attention, while the body copy pulls the whole thing together by driving home the key phrase, *Context is everything*. Throughout both brochures, the arrangement of imagery and copy is not only thought-provoking, but also quite radical for the typically conservative law industry.

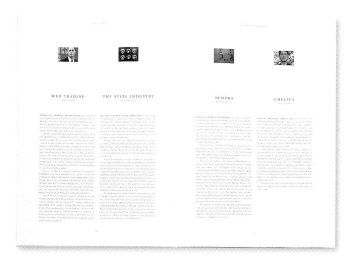

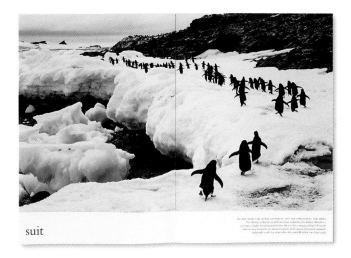

suit

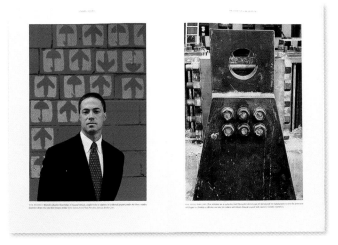

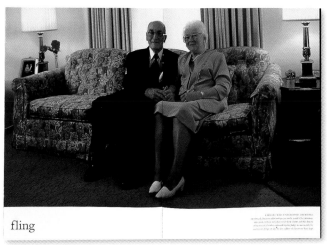

fling

ABOVE: Focused on doing more, the *Stories Volume I* brochure shows the firm's ability to go beyond the conventional. Interesting portraits are juxtaposed against large-scale objects that portray various industries.

ABOVE: Focused on seeing more, the *Business Review* features the firm's ability to recognize opportunity when faced with obstacles. The images and copy work collaboratively to deliver the message.

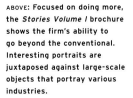

What Works

The distinct and thought-provoking set of brochures established the innovative law firm as the avenue of choice among key clients. The overall package helped to express the culture and voice of the not-so-traditional law firm. The brochures were also used as a recruitment vehicle.

xfera

CLIENT:
Xfera is a mobile communications company that offers a new generation of services and solutions.

FIRM:
Summa

ART DIRECTOR:
Wladimir Marnich

DESIGNER:
Griselda Marti

PHOTOGRAPHER:
Various stock

COPYWRITER:
Conrado Llorens

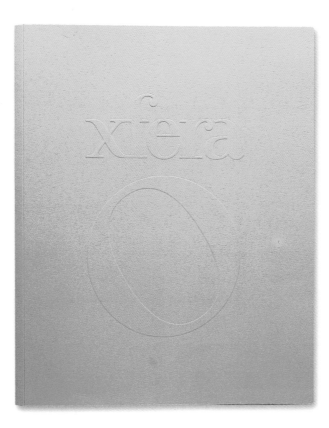

ABOVE: Because Xfera means "sphere," the design firm created a unique mark incorporating the spherical letterform as a play on words. The embossed logo sits predominantly on the vibrant yellow cover. The specially designed font, called Xfera Taz, distinguishes the company's new identity.

A Step Above the Rest

Xfera was in the midst of developing an identity for their company. "This was a brand book created for the official launch of their new mark and name," says art director Wladimir Marnich. Designed as an internal communications device, the brochure was used to inspire and inform employees about Xfera's new identity and key messaging. "We did a lot of research to help understand the market, develop the brand, and position the company," recalls Marnich. "We traveled throughout Europe—looking at the latest in mobile telephones. We realized that there was a lack of real quality amongst their competition." Xfera was a fairly new company entering a very competitive market, so they could not survive or compete on price alone. "Because Xfera was coming out with the latest in technology, we focused on quality, simplicity, and humanizing the whole business instead," adds Marnich.

Inside the brochure, words and images work together to clearly communicate the company's new brand. The images, mostly lifestyle in nature, reinforce the key values and give a human quality to the overall identity. "We spent a lot of time researching photos," notes Marnich. "We not only had to get the concept to go with each one of the values, but we also had to choose images with a similar quality. It was very difficult." Because of budget constraints, the design team had to use stock photography. The brochure concludes with the presentation of the company's new mark and overall visual look.

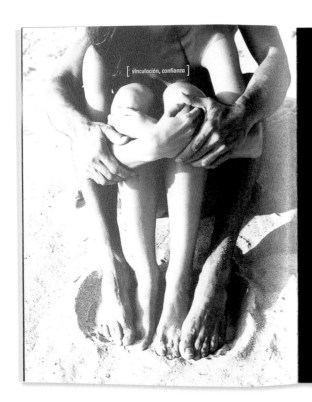

[vinculación, confianza]

01 Una marca

Una marca es, fundamentalmente, una promesa de satisfacción de necesidades y un vínculo entre la empresa y sus clientes.

Para que aporte valor, la marca debe nacer de una visión distintiva y relevante en su mercado, y debe comportarse desde el primer día con plena significación, demostrando su particular forma de ser y de pensar en todo aquello que tenga a su alcance: desde la creación y el diseño de los productos o servicios a la propia imagen de los puntos de venta, desde la estética de los canales on-line a la comunicación, y por supuesto, en todas las oportunidades de contacto personal que existan entre la empresa y sus clientes. Hoy, construir una marca ganadora es una necesidad. En mercados competitivos, es decisivo contar con el poder de convicción y seducción de la marca.

Este brand book tiene la intención de describir la esencia de nuestra identidad, de forma que todos los que mantenemos una relación con Xfera, sintonicemos con ella y contribuyamos al fortalecimiento de uno de los principales activos con los que contamos: nuestra marca.

...una promesa

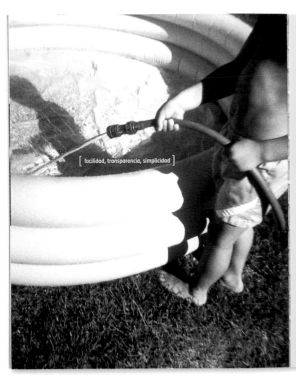

[facilidad, transparencia, simplicidad]

05 Claridad

Frente a la complejidad y confusión reinante, Xfera ofrece una respuesta comprensible, práctica y accesible. Si aspiramos a facilitar la vida de las personas, lo primero que tenemos que lograr es que nuestros productos, mensajes y actuaciones sean claros, comprensibles y transparentes para la mayoría de la gente. Queremos hacer sencillo el uso de la tecnología más avanzada, convirtiéndola en un instrumento al servicio de las personas.

What Works

The simplicity in layout and text helped to clearly communicate the company's new brand and identity to Xfera employees. "People were quite pleased and really tuned into what we were trying to say," details Marnich.

hartmarx corporation

CLIENT:
Hartmarx Corporation is a leading manufacturer and marketer of quality apparel products.

FIRM:
SamataMason

CREATIVE DIRECTOR:
Greg Samata

DESIGNER:
Dimitri Poulios

PHOTOGRAPHER:
Marc Norberg

COPYWRITERS:
SamataMason and
Hartmarx Corporation

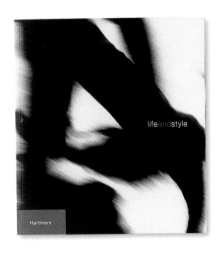

ABOVE: **The cover sets the scene for the main concept—life and style. Red acts as an accent color throughout.**

Clarify and Position

Hartmarx Corporation had an interesting dilemma. "Because they own major brands as well as manufacture some major brands for major companies, there has been some confusion," shares creative director Greg Samata. "What we were trying to do in this annual report was to clarify and position the brands that they either own, manufacture, or license to raise the perceived value of the company and its products."

The biggest challenge for the design team was to clarify in their own minds what Hartmarx did and what their relationships with the other companies were. "Once we gathered all of that information and looked at their competition in the marketplace, we sat down and tried to figure out how we were going to tell the story," recalls Samata. Because it was important to

the company to relate to a more contemporary audience, the design team chose a lifestyle approach to the annual report. "They have an entire range of brands and levels of quality that serve an incredibly diverse marketplace," Samata adds. "The life and style theme gave them a little more cachet and elevated the brands overall." By inserting the clothing in the midst of lifestyle imagery, the design team was able to make a connection between the two. "Printed as duotones, the black-and-white photography allowed us to show the lifestyles in a really rich and interesting way," notes Samata. The monochromatic images played a strong role in setting a scene that allowed the products to stand out. The use of coated stock for the colored images also helped to make them pop against the lifestyle imagery printed on an uncoated stock.

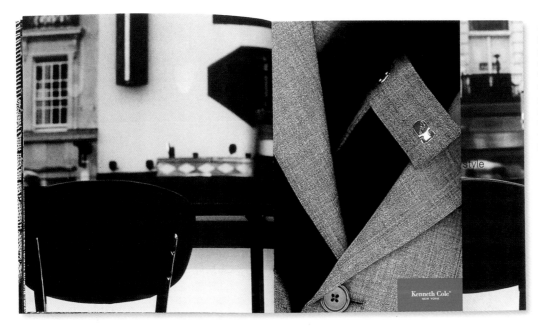

LEFT: Various pieces of clothing appear among images that portray a certain lifestyle, making a connection between the two. The softly focused, almost grainy, black-and-white photographs help to set a nice contrast to the sharply focused product imagery that was created using a flatbed scanner.

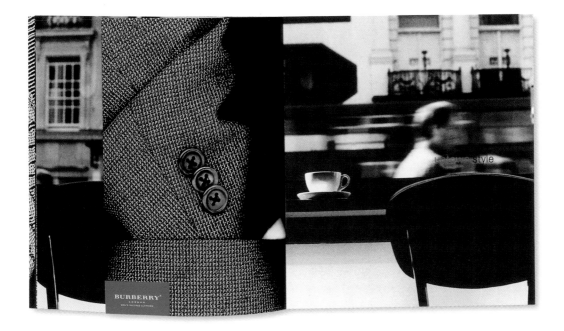

What Works

Used also as a corporate brochure, this annual report not only elevated the company's overall image but also helped to clarify the brands. "The quality of this book was above previous books and raised an eyebrow or two," concludes Samata. "It also allowed people to focus their interests more on the company."

pacific solar

CLIENT:
Pacific Solar is an innovative company that is highly involved with the research and development of thin solar-photovoltaic technology.

FIRM:
Doppio Design

ART DIRECTORS:
Mauro Bertolini and Louise Mitchell

DESIGNER:
Mauro Bertolini

PHOTOGRAPHER:
Julio Castellano

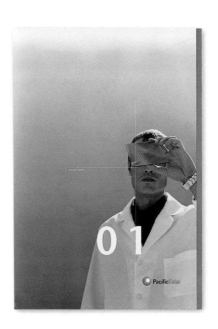

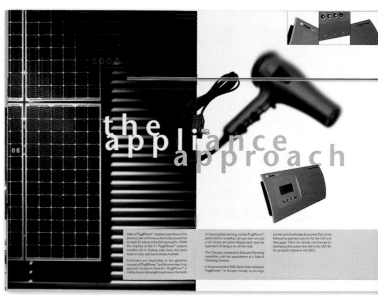

ABOVE AND OPPOSITE: The cover image is clean and sophisticated. The crosshairs create movement and intrinsically bring out the natural grid of the solar panel. Each spread dynamically shows the product and its benefits to mankind and the environment. For pacing and contrast, the left-hand pages are visually dense while the right-hand pages contain more white space, using color bars to generate eye flow and interest.

A New Approach

The objective of this annual report was to communicate Pacific Solar's venture into making solar photovoltaics available to the marketplace, providing a renewable energy source for the future. This was a new endeavor for the traditionally research-and-development-based company. The overall design, a clear departure from the technical reports of previous years, took on a more contemporary lifestyle approach—positioning Pacific Solar as an innovative leader in solar technology. "For years, they have seen their annual report just as a document that they had to produce. They were not very brand aware," says art director Mauro Bertolini. "In this report, we needed to create awareness that they were moving into a product market. I wanted it to have an exciting feeling that would generate interest with people who are environmentally conscious."

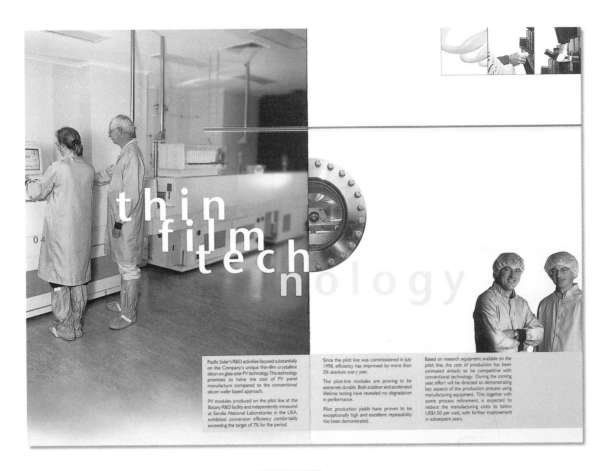

Pacific Solar's R&D activities focused substantially on the Company's unique thin-film crystalline silicon on glass solar PV technology. This technology promises to halve the cost of PV panel manufacture compared to the conventional silicon wafer based approach.

PV modules produced on the pilot line at the Botany R&D facility and independently measured at Sandia National Laboratories in the USA, exhibited conversion efficiency comfortably exceeding the target of 7% for the period.

Since the pilot line was commissioned in July 1998, efficiency has improved by more than 2% absolute every year.

The pilot-line modules are proving to be extremely durable. Both outdoor and accelerated lifetime testing has revealed no degradation in performance.

Pilot production yields have proven to be exceptionally high and excellent repeatability has been demonstrated.

Based on research equipment available on the pilot line, the cost of production has been estimated already to be competitive with conventional technology. During the coming year, effort will be directed to demonstrating key aspects of the production process using manufacturing equipment. This, together with some process refinement, is expected to reduce the manufacturing costs to below US$1.50 per watt, with further improvement in subsequent years.

From page to page, dynamic spreads feature strong graphics, imagery, and type that work together to reinforce the overall benefits of solar technology on a cleaner and greener environment. Because the client had previously used the same photography in other collateral, it was important that it be altered and retouched. Using Adobe Photoshop, the color palette was enhanced and elements were rearranged to fit the contemporary layout and design. "I had to find a way of making them look fresh and new to people," adds Bertolini. "One of the ways of doing that was to change the color and to crop the images differently." The 16-page annual report is printed in four-color process and two PMS colors on Mohawk Navajo. "I was most happy with the feeling and the ambiance of the uncoated stock," concludes Bertolini. "Rather than being a glossy brochure, it had a slightly modern and sophisticated feel to it." Doppio Design was able to transform the company's annual report from a mere financial document into a strategic branding tool.

What Works

The new look for Pacific Solar's annual report not only provided the pertinent financial information but also helped to create awareness and interest for the company's new product endeavors in the solar technology industry. "The feedback I got from the client was very positive. A lot of people were very happy with the new look," shares Bertolini.

giloventures

CLIENT:
GiloVentures is a venture capital and management company.

FIRM:
Jennifer Sterling Design

ART DIRECTOR/DESIGNER:
Jennifer Sterling

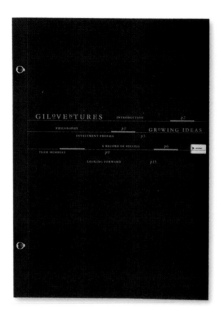

ABOVE AND OPPOSITE: The engraved and die-cut cover is bound to the inside pages by rivets, instead of saddle stitching, to give the appearance of a museum-quality book. Each inside spread is accented with blind debossing and blue engraving to give the piece a tactile quality.

Simplicity and Sophistication

GiloVentures was looking for a sophisticated yet understated brochure that would detail their approach in funding and running a business. Because the design firm had developed a complete program for the company, they knew exactly what they needed to say and do in this piece. The biggest challenge was working within the client's somewhat restrictive budget. "In Chinese, *constraint* is the word for disaster, which is the same as opportunity. Constraints, and changes as well, force you to solve things in a different way," says art director and designer Jennifer Sterling. "This particular piece is quite conservative for a venture capital company. Even though it may look expensive, it is not. There are a lot of tricks we did to make it more substantial." Each page of Fox River Archiva 70-lb. text has been Japanese-folded to add bulk and weight to the simple 16-page book. The cover adds consistency by folding the stock over and pasting it together, creating a double-thick front and back for the piece.

The die-cut cover is engraved with blue on a brown cover stock, Carnival Coco. "The blue engraving and die-cut really help the cover to pop," adds Sterling. "I also like going with a colored sheet rather than a printed one. When you flood the sheet with ink, you get cracks when you fold and score it, showing the white of the sheet." The rivets, used to bind the book, aid in making the piece appear more substantial. Inside the brochure, a consistent circular pattern ties in the rivets with the rest of the piece. The questions who, how, what, and why are framed in a graphic series of boxes to draw attention and carry the viewer through the key elements in the brochure. Because the design firm was very familiar with the identity and brand of the company, they were able to create something that not only described GiloVentures in an interesting and informative way but also suited the company's limited budget.

What Works

With its die-cut and engraved cover, rivet binding, Japanese-folded pages, interior blind debossing, and interesting use of type and white space, the simple but elegant brochure adds personality and distinction to the venture capital and management company.

One Step Beyond

Production Techniques That Communicate

Today, creatives are breaking the norm and seeking outlets outside their industry when it comes to production. Because of technological innovations, designers' options are only limited to their imaginations. "Don't be afraid to explore outside your traditional venues," offers art director Russ Haan. "Investigate custom book-binders or go to printers and look at their finishing capabilities. Go to a sheet-metal facility or a food-packaging plant. Get catalogs from cosmetic manufactures. There is a lot of great stuff out there." Art director Jennifer Sterling agrees, "For years, the really successful designers have always looked toward fashion, music, film, textiles, and even product design."

The latest trends show an increasing interest in alternative and innovative formats and bindery. To create distinction, designers are exploring everything from tiny, interactive flipbooks to die-cut multipieced assemblages and everything in between. Fasteners vary as designers are exploring products—some even seek out the local hardware or office-supply store. Tactile processes like laser die-cutting, sculpted embossing, and hot foil stamping are being done on a variety of materials—custom papers, leather, linen, plastics, and the like. Inks have also come a long way. Heat-sensitive inks, available in various transitional colors, allow a page to transform. For special effects, traditional inks, printed either on top or underneath the heat-sensitive ink, can also be applied. "As designers, we want to push the envelope," notes art director Eleni Chronopoulos. "Finding new ways to combine different materials can be an interesting approach to any project."

Creatives are also re-embracing some old techniques. "In the last five years, I've seen the resurgence of letterpress and handwork—especially on covers," says Haan. "Closures that require the tying of a cord or a rope are also becoming more a part of the bigger picture."

More important than following trends, designers should always select a material or process that supports the overall message of the assignment. The creative use of production techniques should never come before effective communication. If the two do not work in tandem, then the clever use of techniques only becomes window dressing. "Good design comes out of a strong concept," says Haan. "When a design firm presents a client with something that is conceptually united with the design, they usually slam dunk home the idea. It is a rare day that a client will say no if something matches the concept." When the message drives the design, production techniques can truly enhance the visual experience.

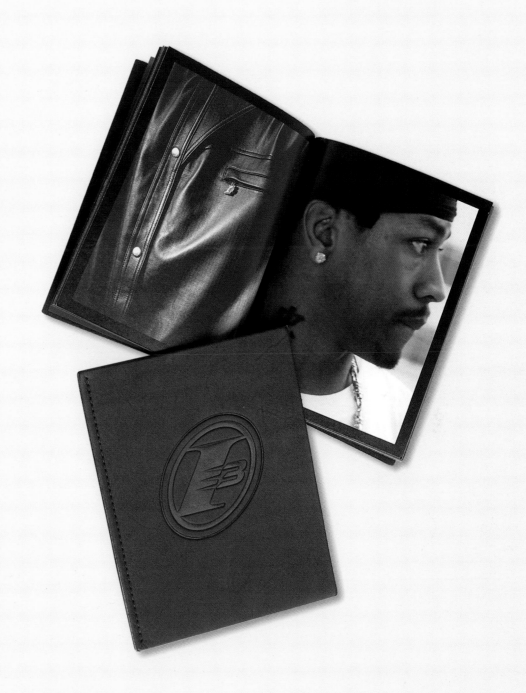

CLIENT:
Reebok's I3 collection is a unique line of apparel designed to reflect the individuality of Allen Iverson, a star player for the Philadelphia 76ers.

FIRM:
Reebok Design Services

ART DIRECTOR:
Eleni Chronopoulos

PHOTOGRAPHERS:
Gary Land and Michelle Joyce

RIGHT: **This pocket-size brochure is designed to be versatile and interesting with lots of texture as it reflects the nonconventional persona of Iverson. The blind de-bossed cover, made of domestic full-grain black leather, had to be die-cut and trimmed separately from the interior booklet. Seamstresses who traditionally work for the sailing industry created the hand-stitched bindery. The graphic color scheme of mostly deep reds and black also reflect the look and feel of the apparel.**

CLIENT:
Fox River Paper Company
introduces a new paper line to
the design community.

FIRM:
Jennifer Sterling Design

ART DIRECTOR/DESIGNER:
Jennifer Sterling

PRODUCTION:
Clare Rhinelander

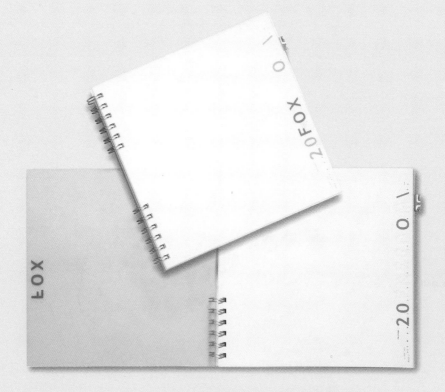

LEFT: A silk-screened polyurethane cover—a big leap for a paper company—works in conjunction with the printed and blind debossed inside cover. Together, they set the tone of the overall concept of freedom. As you look through the brochure, beautiful shades of white paper are microperforated, die-cut, laser-cut, and letterpressed.

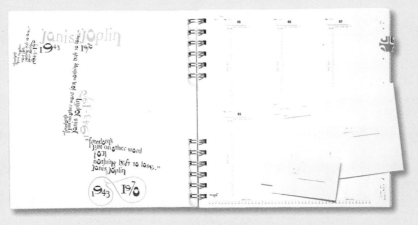

LEFT: This functional piece, created to showcase the myriad uses for Fox River Paper, serves as a 24-hour/7-day timer for busy designers. It is divided into sections by legendary quotes from JFK, Martin Luther King, and Janis Joplin. The inspirational words are hand drawn and letterpressed deeply into each Japanese-folded sheet. Along the outer edges exists a circular laser die-cut to identify each month. Blue and white kiss-cut stickers, printed on Fox River Paper, can be applied as tabs.

LEFT: Throughout the book there is information about the new Fox line, as well as industry facts about paper that both young and seasoned designers may not know.

CLIENT:
bluespace is a top executive training company that works nonconventionally with multinational companies to rejuvenate intuition and creativity in the corporate environment.

FIRM:
After Hours Creative

ART DIRECTOR:
Russ Haan

RIGHT: **This unusual brochure, which cannot be opened without ripping it, serves to promote the radical approach taken by bluespace's staff to retrain executives to look at things in a different way. Always given out in the presence of someone from bluespace, this brochure challenges the recipient and most will not rip it open. A bluespace representative then asks, "What are you so afraid of?" and tears the piece open. The brochure dictates the entire sales process and fits bluespace's business development strategy perfectly.**

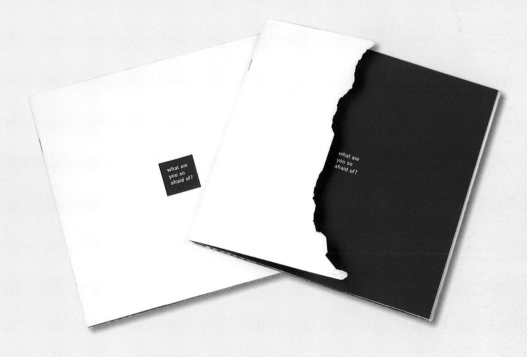

RIGHT: **Designing a brochure that cannot be opened is a challenge. The interior of the book has to entice the reader—not so big it shows too much and not small enough to discourage. Yet, it has to be closed securely enough so that it cannot be easily opened. After numerous experiments with closures and mock-ups, a wrap-around cover adhered with one-inch (2.5 cm)-wide industrial-strength glue, hidden and flush to the back, worked the best.**

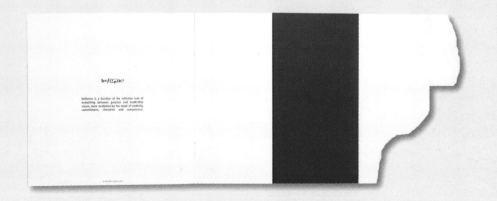

leatherman tool group, inc.

CLIENT:
Leatherman Tool Group, Inc., is the originator of the Classic multi-tool, a pocket-size all-purpose hand tool for the do-it-yourselfer.

FIRM:
Hornall Anderson Design Works

ART DIRECTORS:
Lisa Cerveny and Jack Anderson

DESIGNERS:
Andrew Smith, Andrew Wicklund, and Don Stayner

PHOTOGRAPHER:
Jeff Condit, Studio Three

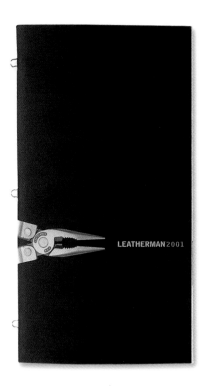

ABOVE: This 6-inch x 11-inch (15 cm x 38 cm) loop-stitched brochure opens by displaying both the Juice and Classic product lines on the inside cover. Directly opposite sits the Leatherman story, a brief history of the company and its founder.

Traditional and Sporty

Leatherman Tool Group, Inc., is expanding its offerings to include an entirely new and more fashionable product line called Juice. This dual-purpose product brochure not only features the Leatherman Classic line but also introduces the innovative Juice series of products to a broader base of customers. "We collaborated with the client, discussing the objectives of the new line. We came back to them and presented three ideas," notes art director Lisa Cerveny. "One of them was pretty interesting, but too much of a leap for Leatherman. It equated the new colorful tools with different beautiful insects. We ended up combining the other two directions to reflect what you see now." The Juice tools, smaller and more colorful, appeal to a more urban customer, while the Classic line tends to appeal to the rugged outdoorsman. The challenge came in combining the Juice products,

upbeat and trendy, with the Classic products, traditional and conservative, into a single brochure that reflects a unified company vision. The Juice product spreads are fashionable and dynamic, while the Classic line remains straightforward in presentation. "Captured with a digital camera, each of the Juice product shots uses soft focus photography to capture an interesting depth of field and movement," explains Cerveny. "The fresh and clean use of white space accents the distinct color of each tool." For additional reinforcement, smaller graphics are used to identify each product and to visually display its unique capabilities. Each product spread includes a unique feature shot, an image portraying a particular usage, a full technical rendering, and a closed version of the product followed by a colored sidebar complete with the product name and color. The color-coding system aids in locating any one product, especially for those readers quickly skimming through the brochure. The cover is printed on Graphica Lineal 80-lb. cover stock in cool white and the inside on McCoy 100-lb. text stock in a matte finish. The Bell Gothic family of fonts is used throughout.

What Works

By presenting the new Juice product line in a fashionable and dynamic way, the brochure appealed to a more urban audience. The straightforward presentation of the Classic line, on the other hand, maintained its rugged and outdoorsmen appeal. Targeted towards retailers, the business-to-business product brochure was very successful in marrying the two distinct product lines under one corporate vision. "It is a very effective piece," adds Cerveny. "Leatherman is actually having a hard time fulfilling their orders for Juice."

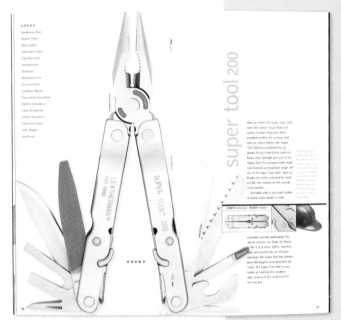

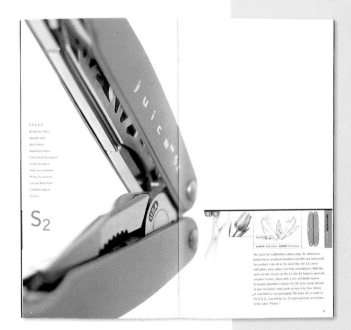

LEFT: As you flip through the brochure, the Juice line, the primary focus, is introduced first and the Classic line follows. Laid out in a clear and concise manner, each spread focuses on the unique attributes of a particular tool.

dwl incorporated

CLIENT:
DWL Incorporated's enterprise
customer management applications
consolidate fragmented customer
relationship management (CRM),
back-office, and e-business
systems into unified industry
solutions.

FIRM:
DWL Incorporated
(in-house creative services)

ART DIRECTOR/DESIGNER:
Shawn Murenbeeld

MANUFACTURER OF HEADS:
Sculpture Connection

ILLUSTRATOR:
Shawn Murenbeeld

PHOTOGRAPHER:
Michael Kohn

COPYWRITER:
Alex Baird

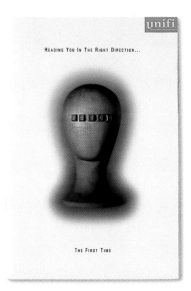

ABOVE: On the cover image, a
wooden head was sanded and
oiled. Then old computer parts,
purchased from a junk store, were
attached with reusable adhesive
putty called Tac'N Stik. The interior
is broken up into six modules,
each featuring a key attribute
of the product.

Getting Ahead

DWL was looking for an innovative and interesting
piece to explain the benefits and features of their core
product offering, an Internet software known as Unifi.
"The key objective of this project was to produce a tech-
nology brochure that would appeal to top-level business
people with little or no technology background," says
in-house art director Shawn Murenbeeld. In trying to
develop a theme that would tie in all of the product's
key attributes and benefits, the idea of using the human
head emerged. "As the control center for the body, the
human head has many parallels with the Unifi product,"
explains Murenbeeld. "When I looked it up in the dictionary,
there were a lot of different variations I could use, like
'get ahead and stay ahead.' It was very powerful."

The first challenge came in trying to locate a prototype
head to work with, but nothing from mannequins to
wooden hat forms seemed to fit the bill. "I eventually
hired a wood carver and gave him a sketch of what I
wanted. He went in with a chainsaw and carved out a

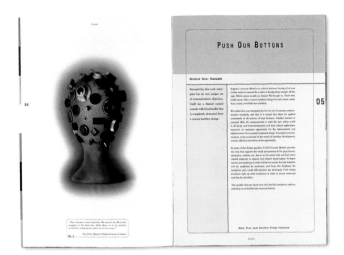

PUSH OUR BUTTONS

LEFT: To illustrate the concept *Push Our Buttons*, various household knobs are adhered to a Styrofoam head that is painted gray and speckled with black latex paint. The copy and a customer quote also work together to convey the message.

BELOW: The head series is also used for a promotional packet. The postcards function as leave-behinds in customer hotel rooms at tradeshows.

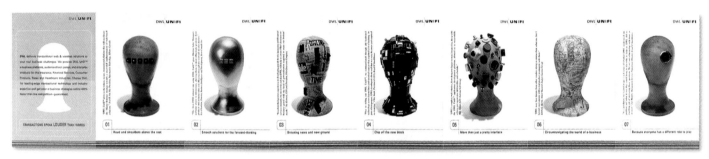

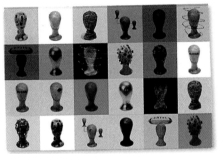

rough shape with no eyes or gender," recalls Murenbeeld. "Once I had the carved heads, I just added stuff to them." Several Styrofoam heads were also carved. Everything from international magazines and newspapers to refrigerator magnets, connectors, and computer parts were used to symbolically convey the message of each key attribute. "For the module on security, I went to a fence place, bought barbed wire, and twisted it into an invisible tornado," details Murenbeeld. "The barbed wire was held in place with this clever device created with washers and bolts." Once the heads were photographed, it was a challenge to get all of the colors to match and the gradations to be consistent. The layout, however, was a breeze. Each spread features the concept illustration, a select quote from a customer, a clever headline, and the appropriate text to explain each featured attribute.

What Works

By symbolically using the human head in various ways, the innovative product brochure was able to clearly explain all of the product's main attributes and benefits in an interesting and captivating way, attracting attention from top-level management. As a result, the brochure has been well received by both prospective clients and business partners alike. "IBM was so impressed that instead of developing materials for us to promote Unifi, they let us design our own material," adds Murenbeeld. Because of the versatility of the head image, it became the standard icon for Unifi.

storck bicycles

CLIENT:
Storck Bicycles is an international manufacturer of high-quality bicycles and accessories.

FIRM:
Starshot

ART DIRECTOR:
Lars Harmsen

DESIGNERS:
Chris Steurer and Lars Harmsen

PHOTOGRAPHER:
Kai Stuht

COPYWRITER:
Kai Stuht

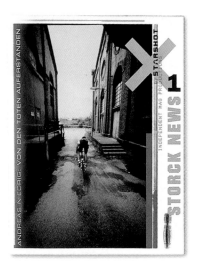

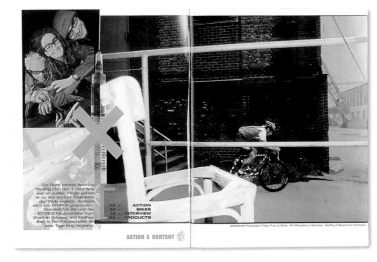

ABOVE: *Storck News* is the title of this editorial-style brochure. It is the first in a series of biannual issues featuring outstanding athletes who are sponsored by Storck. A monochromatic palette accented by silver is used throughout. The entire piece is produced in five colors—process plus one metallic.

Urban Edge

Storck was looking for more than just a product brochure. They wanted to communicate an image, philosophy, and way of life to connect with a younger audience. "The product itself is not enough to express this," explains art director Lars Harmsen. "They wanted to sell spirit, freedom, and escape. To do that you need to tell a story." This small format brochure is the first in a series called *Storck News.* Each biannual issue is an editorial-style piece that focuses on the lifestyle and personality of an athlete sponsored by Storck. In this issue, Andreas Niedrig, a triathlon champion, is profiled. "He is quite an interesting person. For a long time he was a heroin addict and has since totally changed his life by taking up sports," shares Harmsen. "The message that Storck was trying to convey was that success is possible if you work hard enough. You just have to stand up and go for it."

The first task for the design team was to dive into the individual behind the publicly recognized athlete. "We really wanted to find out about the personality of Andreas Niedrig, besides his sport success," says Harmsen. "It is important to show that the athlete, like

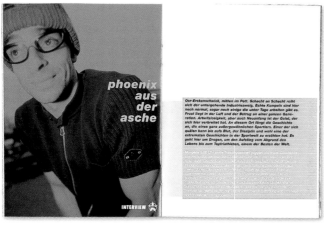

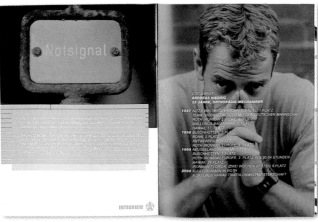

LEFT: Andreas Niedrig, a triathlon champion, is profiled as a person who has been up against great odds and has triumphed over adversity. The personal courage and tenacity of Niedrig is transferred to the products manufactured by Storck.

BELOW: The products, both bicycles and accessories, are featured in an understated way against the compelling story of Andreas Niedrig.

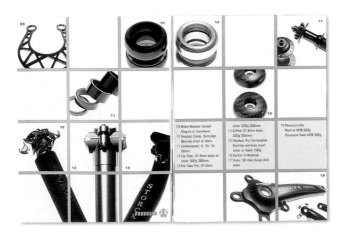

the company, has something to offer and say about life. It gives the company a character or a face that is different than others." The next hurdle was the photography. "The ads that Storck usually runs show wonderful roads in the south of France, and the whole atmosphere is really warm and sunny," notes Harmsen. "We found that Niedrig was better portrayed in a city." An industrial urban scene, reproduced in a monochromatic color palette, was chosen. "Niedrig is not someone who is colorful in his expressions," Harmsen adds. "He is more quiet and contemplative." The booklets were handed out at tradeshows. The convenient size made it easy for people to pick up and place in their pocket.

What Works

The handheld booklet was successful in capturing a new and younger market for Storck by introducing an editorial approach to what used to be a typical product catalog. The engaging story and graphics added character and personality to the bicycle company. "They could see it from the response that they had from the tradeshows and on their website," acknowledges Harmsen. "All in all, the year 2001 was bad for the bicycle business, and a lot of companies had a bad season, but Storck is doing pretty well."

appleton coated

CLIENT:
Appleton Coated, part of the fine, specialty, and coated papers division of Arjo Wiggins Appleton, is promoting their Utopia line of paper.

FIRM:
SamataMason

CREATIVE DIRECTORS:
Pat Samata and Greg Samata

DESIGNER:
Steve Kull

PHOTOGRAPHER:
Sandro

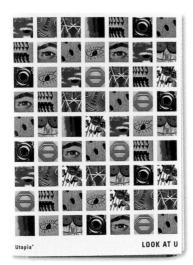

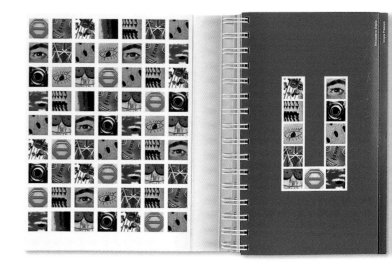

ABOVE: The cover is printed in four-color process with a matte film lamination on Utopia Premium blue white gloss 150-lb. cover stock. The divider pages are printed in four-color plus an over-all satin varnish.

Creative Exploration

"We didn't want Appleton Coated to be just another paper company," offers creative director Greg Samata. "The whole idea behind the concept *Look at U* was that we wanted people to look at themselves and think of Utopia as the medium for their creative output. We wanted people to see that they could do just about anything on this paper. We were trying to raise the perception of the brand and the product."

To show the creative potential of this product line, several well-known designers, who also use the product, were asked to create a mask that best communicated their individuality. "We wanted them to create a mask where they look inside themselves and reflect what they are as creative people," adds Samata. "The idea was to get them to explore who they really are." Each designer was photographed in a black suit wearing his or her own mask creation. After the masks were shot, details of each were selected digitally and interestingly recomposed in a gridlike pattern onto the cover and in various other

places within the book. "We wanted something that would give us a way to combine all of these thoughts and ideas subconsciously," says Samata. "It served as a thematic tapestry and a background for the messages." The highly textural masks also helped to show the high printing quality of the paper. Throughout the book, several papers under the Utopia line were easily recognizable and accessible through brightly colored dividers. The spiral-bound swatch book was distributed to designers, advertising agencies, printers, and paper merchants along with a poster that utilized the same visuals. The masks were such a hit that they were also used in a national advertising campaign.

What Works

The Utopia brand—seen as smart, witty, and fun—is communicated well in this very imaginative and creative product brochure. By integrating the creativity of designers with the paper product, the design team was able to make a connection between the two. "With all the consolidations and the closings, we are in one of the worst paper markets. Yet, Appleton has been incredibly successful," acknowledges Samata.

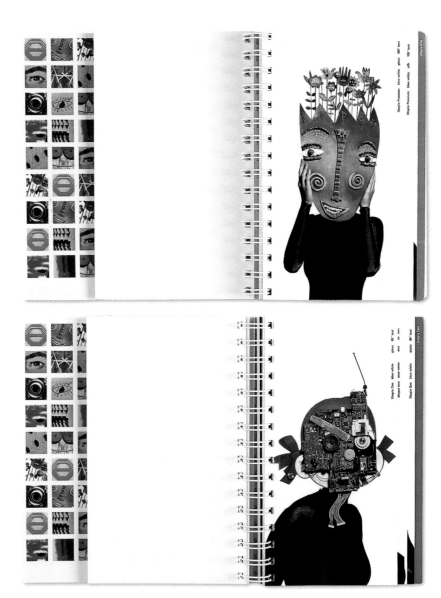

ABOVE: The masks, created by several well-known designers, are used to communicate the creative potential of the product line.

mohawk paper mills, inc.

CLIENT:
Mohawk Paper Mills, Inc. is one of North America's leading producers of premium printing papers.

FIRM:
EAI

CREATIVE DIRECTOR:
David Cannon

DESIGNERS:
Nikki Riekki and Ali Harper

PHOTOGRAPHER:
Catherine Ledner

COPYWRITER:
David Cannon

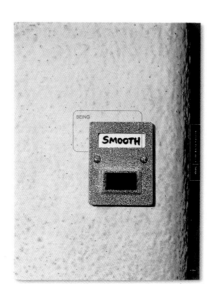

ABOVE AND OPPOSITE: The cover, featuring a doorbell, is our introduction to Mr. Smooth. The inside pages present a day in the life of the main character, Steve Smooth. The imagery, highly textural and detailed, highlights the Navajo line's main characteristic—smoothness.

Smooth Interpretation

Mohawk Paper needed a series of brochures for several of their paper lines. EAI was one of five different design firms chosen to produce a brochure in the five-part series. Each design firm was assigned a product line and given a unique attribute that had to be conveyed. "The paper we were given was Navajo, and the attribute that they wanted to highlight was smoothness," shares creative director David Cannon. "The piece had to work on varying levels of expectations. There was the design community that simply wanted something cool and eye-catching. There were paper distributors who wanted to show the versatility of the paper, and printers who were mostly concerned with the paper's performance." The design team had to work within a given size and page count, but the rest was theirs to interpret as they saw fit. "Most paper promotions don't have a true concept," remarks Cannon. "We wanted to make sure that this piece had a lot more storytelling to it. Our main goal was to create a piece that people would keep."

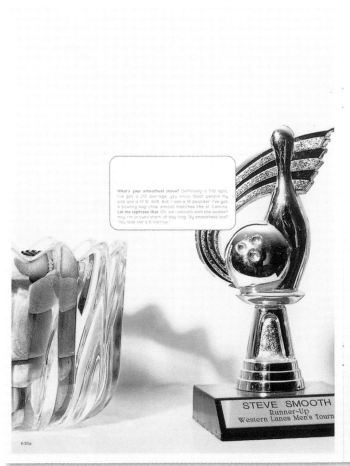

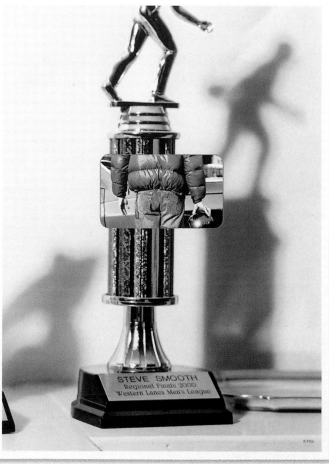

The design team played with several ideas, but one seemed to stand out from the rest. "We liked the idea of taking Mr. Smooth out of the phone book and doing some kind of documentary on him," adds Cannon. "We sat down and brainstormed about all of the different things that could convey Mr. Smooth and his identity, whether it was his mailbox, driver's license, or bowling trophies." To play Mr. Smooth, the photographer proposed several potential prospects. With his receding hairline and crooked teeth, one guy just fit the bill. Given carte blanche, the photographer shot numerous situations for the design team to choose from. Throughout the piece, the pseudo-cool life of Steve Smooth was documented using a variety of interesting textures and situations that highlighted the smoothness of the paper and its ability to capture sharp details.

What Works

The satirical brochure is not only interesting and entertaining but also effective in communicating the smoothness and printing potential of Mohawk's Navajo line. The clever use of storytelling helps to engage the audience while delivering the product line's overall message, a different approach than most paper promotions. "It was very well received from the design community," adds Cannon. "Print reps said it was a very effective sales tool."

polygon group of companies

CLIENT:
Polygon Group of Companies is a homebuilder and Klahaya is one of their upscale developments in West Vancouver, one of Canada's most prestigious neighborhoods.

FIRM:
Thumbnail Creative Group

CREATIVE DIRECTOR:
Rik Klingle

DESIGNERS:
Valerie Turnbull and Lindsay Rankin

PRODUCTION:
Paul Townson and Judy Austin

PHOTOGRAPHER:
John Sinal

COPYWRITER:
Martha Ophir

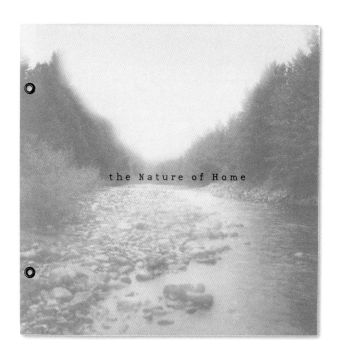

the Nature of Home

ABOVE AND RIGHT: **The vellum cover entices our curiosity, while the textural uncoated stock, French-folded, adds bulk and substance to the overall piece. The 12-inch x 12-inch (30.5 cm x 30.5 cm) book is held together by grommets, and the inside spreads feature an artistic interpretation of the natural elements that surround Klahaya.**

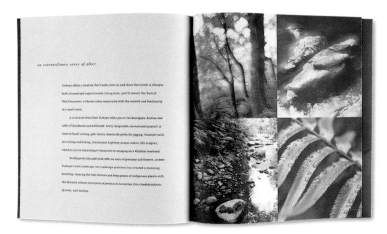

Inspired by Nature

"West Vancouver is a very beautiful area that is full of natural resources," observes creative director Rik Klingle. "In this piece, we wanted to reinforce the pristine nature of the development, so we came up with the theme *The Nature of Home*." Throughout the brochure, nature is depicted in an evocative and inviting way that appeals to the senses. Human elements are absent throughout the piece, allowing viewers to put themselves into the tranquil and soothing environment of Klahaya. "In our initial research, we did a lot of walking through the forest—helping us to develop a clear idea of what we wanted to show in the photography," recalls Klingle. "There is a sensuality that comes when you walk through the forest after it has rained. You can feel the ferns brushing up against your legs, the water droplets on your pants, and you can just smell the freshness." To break away from typical nature shots, Klingle hired photographer John Sinal to create a series of photographs from around the site that not only evoked emotion, integrity, and truth but really explored nature as art.

Because the brochure targeted a very educated and affluent audience, the text was handled in an elegant yet poetic fashion, quoting William Wordsworth along the way. The palette, an array of muted tones, is soft and dramatic. "Our idea with this piece is to create a coffee table book that would continue to inspire people about where they live. We really tried not to make it a typical development brochure. From the ground up, we wanted to do something special," concludes Klingle. "People see with their hands first. I've always believed the architecture of a piece is very important. It sets up an expectation that there is something to be explored."

What Works

The brochure, distributed by hand and mailed to a very targeted audience, generated a great deal of interest and sales for this unique and exclusive development. "The reason this brochure was so successful was because everybody involved—the architects, interior designers, landscaper, and the client—came together at the beginning," explains Klingle. "We talked about the vision and where it could go. Everybody was in sync. It was very much a collaborative process." The brochure was so inspirational that the interior designers used the same color scheme for the exterior trim of the development, and the photography outtakes were used as wall art in the suites themselves.

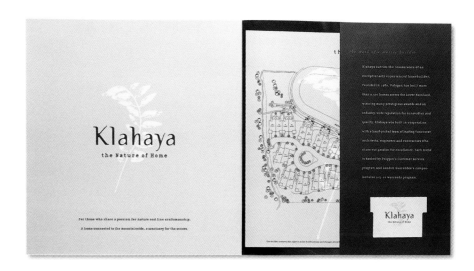

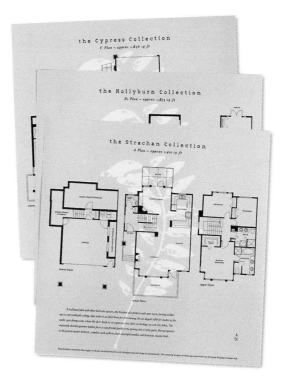

ABOVE AND LEFT: The back pocket holds the functional aspect of the brochure—six inserts detailing the various floor plans, amenities, and the site itself. The Klahaya logo is a fern that was created by hand using a linoblock technique.

yupo corporation america

CLIENT:
Yupo Corporation America is a paper company that makes a variety of synthetic papers.

FIRM:
Renee Rech Design

CREATIVE DIRECTOR/
DESIGNER:
Renee Rech

ILLUSTRATORS:
Keith Graves, Richard Borge, Cathy Gendron, Joe Sorren, Katherine Streeter, Rick Sealock, and Yucel

COPYWRITERS:
David Bell and Renee Rech

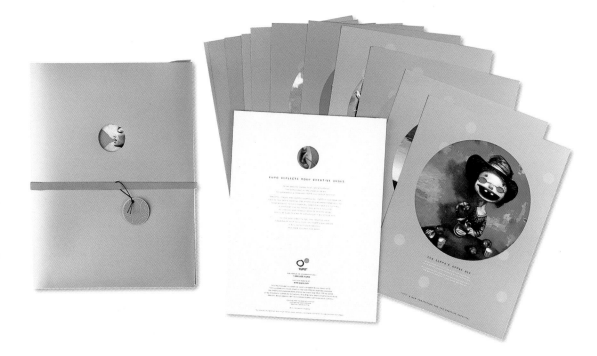

ABOVE: The pocket folder was printed with a UV-curable primer and two hits of metallic silver, a UV match orange, a UV black, and an overall UV satin varnish for durability. The inserts were printed with a match silver using stochastic technology. The thick pocket allows room for the inserts, other paper samples, and swatch books, making it a very versatile piece.

Palindrome Inspired

The year 2002, a perfect palindrome, inspired designer Renee Rech to develop a fun and highly creative promotion for Yupo Corporation America to show off their new line of synthetic cover stock. "They wanted something innovative to launch their new 14-pt. paper out in the marketplace," recalls Rech.

Using the tag line *A New Temptation for the Creative Appetite*, the designer began developing interesting palindromes—12 to be exact—which would serve as the launching pad for the imagination of several illustrators. Each artist was given a different palindrome, a template in which to work, and the creative freedom to do what his or her heart desired. Mostly food related, each wacky and whimsical illustration helped to reinforce the creative possibilities that can happen when using the paper product. The finished illustrations were used to create a calendar of satirical palindromes. "Because it's a synthetic paper, it can magnetically hold onto anything that your creative mind wants to throw at it," adds Rech. With spiral clips and

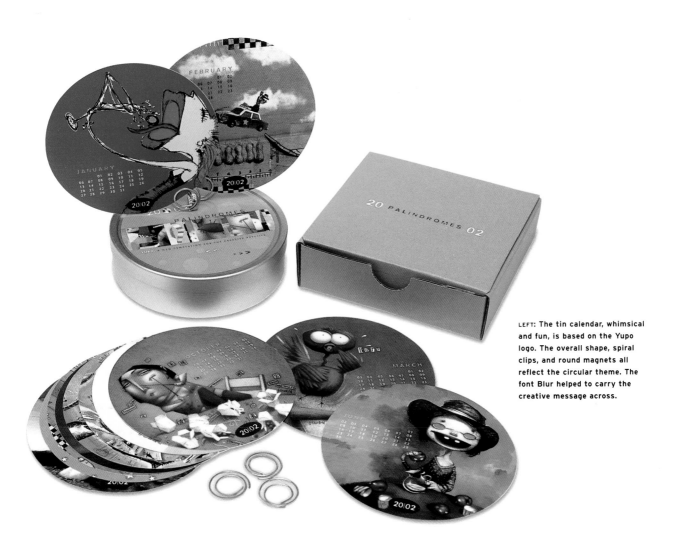

LEFT: The tin calendar, whimsical and fun, is based on the Yupo logo. The overall shape, spiral clips, and round magnets all reflect the circular theme. The font Blur helped to carry the creative message across.

round magnets for a stand, the calendar sits inside a tin container that was hit with a coat of satin varnish to dull the shine. The tin fits nicely into a custom-made box that also acts as a self-mailer.

In addition to the calendar, a matching pocket folder with sample inserts was created. "To keep it flexible, I designed a pocket folder with a Velcro slip in the front that could feature current ads or one of the inserts," says Rech. Each insert, printed on the new 14-pt. paper, visually matches the months of the calendar promotion. "The pocket folder also launched the use of silver with Yupo," notes Rech. "Their corporate colors are orange and black, and we added the silver as another color." A circular and curvilinear theme was carried throughout. "It plays on the Yupo logo," shares Rech. "The shape of the pocket, die-cuts, spiral clips, round magnets, and cover tag all reflect the logo." The overall design is clean and simple while the stories and the illustrations speak for themselves.

What Works

The illustrated promotion gave Yupo a fresh and highly imaginative look and generated interest for the new line of paper in the creative community. The promotion was not only interesting but also functional—something that designers would want to keep and use in their daily lives. "We want designers to sit the calendar on their desk for 12 months. That way, when they have a project, they can remember to use Yupo," reminds Rech.

ventures

CLIENT:
Ventures is an export house that designs and manufactures fabric.

FIRM:
WYSIWYG Communications Private Limited

ART DIRECTOR:
Nidhi Harlalka

DESIGNER:
Mousim Mitra

PHOTOGRAPHER:
Satyaki Ghosh

COPYWRITER:
Anjana Basu

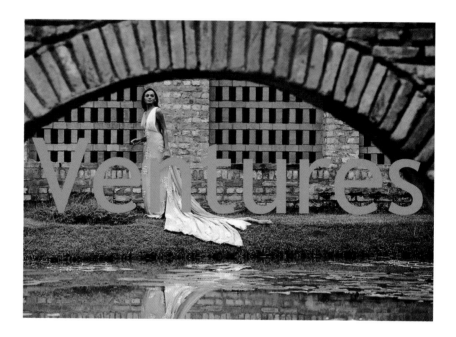

ABOVE: **The color scheme, mainly monochromatic, is indicative of the mostly earth-toned collection. The center-stitched brochure is printed in four-color process plus silver, and the cover is laminated.**

Texture, Pattern, and Color

Because Ventures markets to wholesalers who procure fabric for designer boutiques, they needed a brochure that would not only communicate the intricacies of the collection but would also show the potential it had in the high-fashion market.

"Ventures is very well aware of the trends of the season, and they have a huge variety of fabrics to offer," says art director Nidhi Harlalka. "What we tried to achieve through this brochure was to give a feel of how the fabric would be used—letting the buyer know exactly what he or she can offer in terms of the variety in texture, pattern, and color."

Shot at a hotel outside of Calcutta, the brochure juxtaposes larger images—showing the fabrics' detail and embroidery—with smaller ones—depicting the mood, ambiance, and use of material. The design team and photographer visited the location several times to determine potential layouts for the brochure—trying to make an interesting combination of the models, dresses, and natural architecture of the space. "We used different parts of the hotel, like a door, a ramp, or an accessory vase," says Harlalka. "We tried to inspire our creativity from the pattern on the fabric, whether it was floral or abstract in nature." On each page, the character of the architecture complemented and brought out the unique patterns and textures of the fabric. Both interior and exterior locations around the hotel were used. "After the pictures arrived, we did a complete layout of the brochure," concludes Harlalka. The high-fashion collection, mostly formal and eveningwear, was accented with the use of silver throughout the brochure.

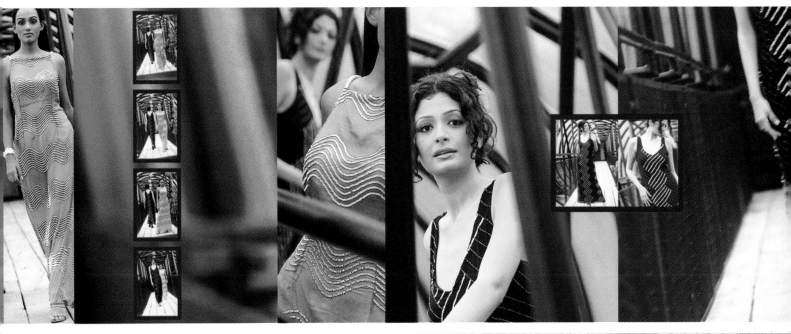

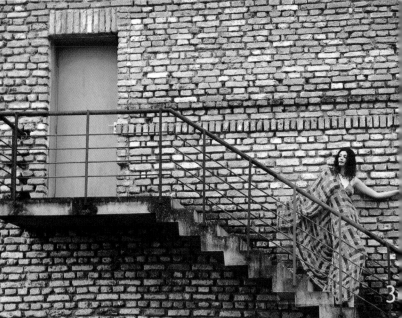

What Works

Distributed at trade fairs and hand-delivered to wholesalers, the brochure not only shows off the beauty and detail of the fabric but also highlights the potential it has in the high-fashion market. "This brochure was responsible for getting a lot of additional clients," notes Harlalka.

ABOVE: Inside, each spread comes alive with a variety of well-positioned images—depicting both the fabrics' detail and its potential use in the fashion world.

serconet

CLIENT:
SerCoNet develops a range
of products for networking
applications that target home
and small office networks.

FIRM:
Jason & Jason Visual
Communications

CREATIVE DIRECTOR:
Jonathan Jason

ART DIRECTOR:
Tamar Lourie

DESIGNER:
Dalia Inbar

PHOTOGRAPHER:
Yoram Reshef and
stock photography

COPYWRITER:
SerCoNet

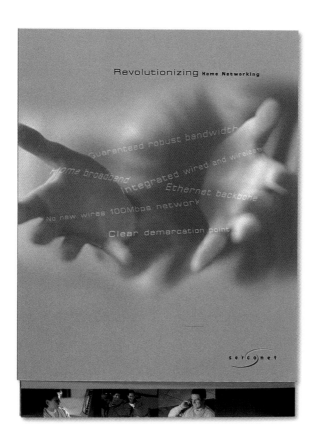

ABOVE: **To create distinction for the home networking company, the design team created a unique cover image that sets the tone for the promotional package. The hands symbolize the home, the string symbolizes connectivity, and the typography represents key product attributes.**

Home Technology

SerCoNet was just starting up and was looking for a brochure that would position them as a major player in the industry. To portray the company as innovative, the design team developed a very dynamic and eye-catching promotional package filled with die-cuts and interesting angles. "Because they also wanted us to portray them as revolutionizing home networks, we tried to create a balance between technology and home throughout the brochure," says art director Tamar Lourie. "Also, because the product itself is something on the wall with a whole area of technology hiding underneath, we wanted to create a feeling of multiple layers."

Inside the pocket folder is a company overview brochure and several product specification sheets. "The data sheets were more technical, while the pocket folder and overview brochure were more metaphorical," adds Lourie. For the cover of the pocket folder, a custom-designed illustration was created to help portray the company's unique message. "We came up with a metaphor for the cats-in-the-cradle game. The hands symbolize the home, the string symbolizes connectivity, and the typography represents the different applications that they do," notes Lourie. "It was a unique image that really represented the company with both the home and technology parts working together." The entire package was printed in four-color process with the pocket folder laminated for durability. The piece was distributed to vendors and retailers in the communications industry.

What Works

The innovative and dynamic promotional package helped to distinguish the start-up company in the communications industry. "In the days of a turbulent economic environment, it is a must for companies to use a single one-shot image to grab attention and deliver their message," offers SerCoNet COO Yaniv Garty. "Jason & Jason were able to visually capture our messages and turn our vision into a set of collateral that really works."

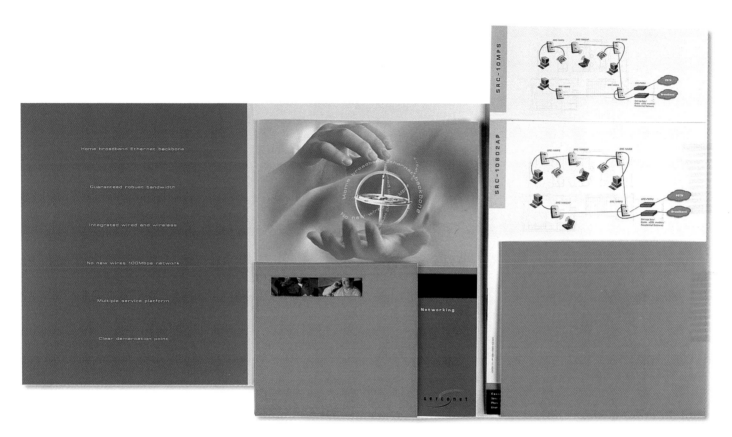

Home broadband Ethernet backbone

Guaranteed robust bandwidth

Integrated wired and wireless

No new wires 100Mbps network

Multiple service platform

Clear demarcation point

SRC-10MPS

SRC-10B02AP

Networking

serconet

ABOVE: Inside the pocket folder is a company overview brochure and several product specification sheets. To portray the company as revolutionary, the design team developed a layered package filled with die-cuts and interesting angles—balancing both aspects of technology and home.

wilson/equity office

CLIENT:
Wilson/Equity Office is a private, San Francisco–based development firm created by Equity Office Properties Trust in association with William Wilson III and partners.

FIRM:
Cahan & Associates

CREATIVE DIRECTOR:
Bill Cahan

DESIGNER:
Michael Braley

PHOTOGRAPHERS:
Bill McLeod and Jeri Rato

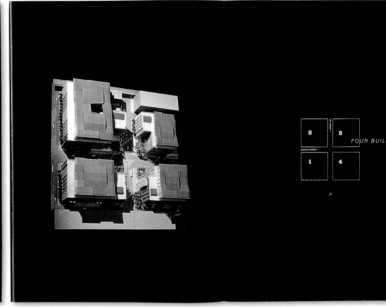

ABOVE: The cover graphically displays the company's corporate identity. It represents the four-corner map of Foundry Square. As you rotate the brochure, the orange square identifies each building in the square. The interior spread shows the intersection and a small-scale model of the development.

A Place to Work

Foundry Square is one of the largest commercial construction projects in San Francisco. The mid-rise office space is conveniently located south of the Market District area. "This was a huge project being developed right in the middle of the dot-com craze. At the time, downtown had this wild energy with literally thousands of people scribbling down business plans and talking about stock options," recalls creative director Bill Cahan. "Foundry Square was trying to attract companies that were a little more entrepreneurial in nature to this hip loft-like development that had large expansive glass and high ceilings. It was a very unusual project, and they wanted to position it that way."

Wilson/Equity Office was looking for a distinctive brochure for its extraordinary development. "Foundry Square is more than just a new place to work. It's a new way to work," shares designer Michael Braley. "It has very convenient access to transportation, underground parking, restaurants, shops, and museums. There is a lot of open space and landscaping not found in other buildings." Because this was an exciting new place to work in San Francisco, the design team really wanted to show off the location and the innovative space. "The idea was to get a sense of what it was like to work in the area," comments Braley. "We met with the architects and did an entire walk-through on the project while it was still in the planning stages. We also looked at other development brochures." A photographer was sent in to shoot a three-block radius around the development—capturing the excitement and the craze of the downtown experience. Both day and night scenes were photographed in close-up and panoramic views to add variety and pacing to the book. The resulting imagery became a photo essay at the beginning of the brochure. The rest of the book detailed architectural plans and structural details.

What Works

The simple and dramatic brochure attracted people to the happening, downtown environment. The brochure clearly communicated the essence of Foundry Square as a development that brings together the very best in architectural design and innovation. The piece also allowed the sales force to walk a prospective client through the new and exciting landmark in San Francisco.

ABOVE: The oversized brochure, meant to stand out from other development brochures, captures the excitement that surrounds the downtown office space.

creative nail design

CLIENT:
Creative Nail Design, experts in
nail care, manufactures a product
line called Creative Spa.

FIRM:
Miriello Grafico

CREATIVE DIRECTOR:
Ron Miriello

DESIGNER:
Dennis Garcia

PHOTOGRAPHER:
Alberto Tolot

COPYWRITERS:
Andrea May and Melissa Osborne

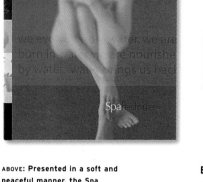

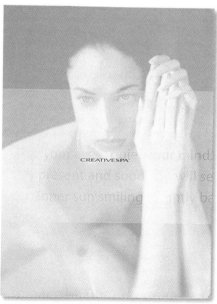

ABOVE: **Presented in a soft and
peaceful manner, the Spa
Manicure and Spa Pedicure
brochures communicate the
overall serenity of the spa
experience. Both brochures
can easily fit into the adjacent
pocket folder.**

Experience the Serenity

Creative Nail Design was interested in re-launching
its Creative Spa product line for nail care to both
customers and trade personnel. "They had introduced
this product line a few years earlier and did not have
the level of success that they would have hoped,"
recalls creative director Ron Miriello. "So, they decided
to invest in repackaging and presenting it in a way
that focused on the overall spa experience rather
than so much on the products' chemistry and makeup."
Both the Spa Manicure and Spa Pedicure brochures
are designed in a highly visual and poetic fashion—
playing off the primary ingredients found in each
line. "For Spa Manicure, they wanted to include
elements and colors that would convey the smell,
feeling, and flavor of citrus. In the color scheme, we
used bright greens and oranges that are very

reminiscent of spring," adds designer Dennis Garcia. "In the Spa Pedicure piece, the ingredients are much coarser, like exfoliatives. They are more reminiscent of things found at the beach."

Prior to conceptualizing the two-part series, the designer went to a salon to get into the mindset and experience the products firsthand. "We were looking to create serenity and inner peace," shares Miriello. "We felt the spa experience was about going inside instead of just looking good on the outside." They also did extensive research, looking through various books on meditation, Zen, and fashion, as well as going online and investigating exclusive spas around the world. The research enabled the design team to pinpoint the type of photography that they wanted to use. "The client was very particular about the models having nails that were in the best shape, and a lot of attention was given to the right age and image type. The models had to be beautiful but not unapproachable," says Miriello. "We also created an entire library of images that the client could use in catalogs, exhibits, advertising, and online."

What Works

Under the redesign and launch, the spa products were now being presented in a highly visual and poetic fashion—appealing more to the end user. By focusing on the serenity and overall sensual experience of a spa manicure and pedicure, the brochure series really helped to position the brand in a more captivating way. "The product line is doing extremely well relative to a flat market, and they have been actually exceeding their sales expectations," notes Miriello.

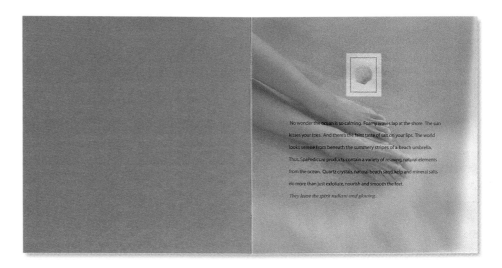

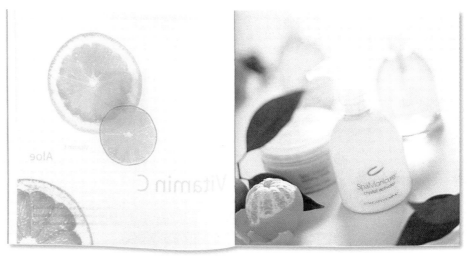

ABOVE: Translucent vellum sheets overlay soft, dreamlike imagery with type that is poetic and abstract. Each piece is printed in five colors—process plus silver—on Cougar opaque uncoated cover stock 80-lb. throughout.

just one

CLIENT:
Just One is a company that specializes in club music, clothing, and events.

FIRM:
After Hours Creative

CREATIVE DIRECTOR:
Russ Haan

DESIGNERS:
After Hours Creative

PHOTOGRAPHER:
Tim Lanterman

ILLUSTRATORS:
Rich Borge and
After Hours Creative

ABOVE: The cover image, created in layers in Adobe Photoshop, is symbolic of the beginning of life—playing off the egg and sperm during the moment of conception. Inside the brochure, the various product lines are featured.

Nightlife

Just One is a hip new company that targets the club scene in major cities across the country. "They are an interesting company," says creative director Russ Haan. "They plan events, make club wear, and distribute CDs." Because of the diverse products they provide, Just One needed a brochure that would not only unify them as one company but would also call attention to the various product lines they carry. "They were looking for a brochure to launch their new company and brand," adds Haan. "We also wanted to make it clear that all of what they do is related." To get an understanding of the market, the design team visited various clubs. "We wanted to see what everybody was doing and wearing, and what the overall attitude was," details Haan. "The whole crowd was young, upbeat, and positive—just wanting to have a good time."

After experiencing the mood and flavor of the nightlife scene, the design team developed a cover image for the brochure. An illustration, symbolic of the beginning of life, portrays a woman inside an egglike mass surrounded by various potential male candidates, all dressed in Just One clothing. "When life occurs, only one gets the chance to make it happen. It's really just about two adults getting together," explains Haan. "It's upbeat and fun in an irreverent way." All of the models were shot on white backgrounds and brought into different environments and assembled in Adobe Photoshop. Inside, there are clothing labels, a mini product catalog, and a CD. The mini catalog shows both clothing lines—the JO line, an edgy, grungy, and graffiti-like collection, and the Just One line, a more fashionable alternative. The CD features primarily electronica music. The entire package was mailed to a variety of club owners, potential retailers, and buyers. It was also sent to the media.

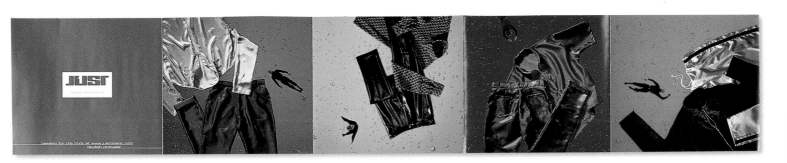

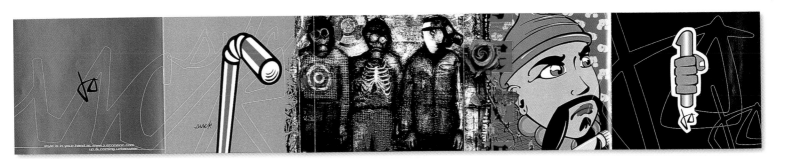

What Works

Because the piece was fun, upbeat, and in tune
with the club entertainment scene, it grabbed a lot
of attention across all products lines. The visual,
tactile, and musical piece works hard at capturing
the attention of a youthful and active audience.
The overall packaging is not only innovative, but
also serves a multitude of purposes, from selling
the clothing lines, music, and events to promoting
the overall image of the new and happening company.
"It went over really well, and they made out great
in sales. It was a very positive launch," notes Haan.
"They also got a lot of media coverage in the fashion
trade magazines and in the music media."

ABOVE: The mini product catalog
displays both clothing lines. One
side shows off the illustrations
present in the streetwise line
called JO. The other side premiers
a more fashionable club wear line.

One Step Beyond

Visually Speaking

With the proliferation of stock and royalty-free imagery, many designers have forgotten the benefits that original illustration or photography can provide. Although stock may offer a quick and convenient solution, it is not necessarily the best. Working directly with an illustrator or photographer offers many advantages—customized solutions, the creation of work in a series, and the assurance that you are dealing with the person who is most knowledgeable about what you are buying. When it comes to specialty work, such as medical illustration or product photography for instance, corporate stock houses are not always versed in the intricacies and really only sell generic mass-marketable works. For distinction, commissioning original illustration or photography is the best way to go.

With all of the source books, mailers, and websites out there, it is sometimes difficult for a designer to distinguish the reliable talent. "It's not a question of what they have in their portfolio, but what they can produce day to day," adds art director Jennifer Sterling. "You want to find out if they can produce, work under pressure, work within your boundaries or the client's, or make changes and still be fresh." Good resources in which to look for talent are the juried annuals, like the ones produced by the Society of Illustrators or the Art Directors Club. The trade publications like *Communication Arts, Print, Step-by-Step Graphics, How,* and *Applied Arts* all have annuals and are worth looking at.

Commissioning work, for some, also means giving up a certain amount of control over a job. But there are benefits to this process. "I like to collaborate with more than one artist—getting a variety of interpretations," shares art director Mark Murphy. "The artists bring out things that I would not have. They add their perspective—capturing feeling and emotion. Working as a group creates a sense of community that is very inspiring. It is also one of the ways we, as designers, can keep learning and growing." When outsourcing illustration or photography, it is important to be clear about your intent and to provide as much information as possible in the beginning of the assignment. Maintaining an open dialog with the talent throughout the working process is also important. "Give them parameters that are somewhat loose so that they have an opportunity to explore," offers Murphy. "At the same time, you also have to continue your dialog with the client—being passionate about wanting to use illustration or photography to convey their message." With proper organization and collaboration, commissioning creative work can truly enrich any communications brochure with storytelling and imagination.

CLIENT:
Murphy Design Inc. is a marketing and communications company that focuses on creative business strategies.

FIRM:
Murphy Design Inc.

ART DIRECTOR/DESIGNER:
Mark Murphy

ILLUSTRATORS:
Gary Taxali, Jorge R. Gutierrez, Joe Sorren, Rob Clayton, Christian Clayton, Charles Glaubitz, Jonathon Rosen, and Rafael Lopez

PHOTOGRAPHER:
Eric Rippert

COPYWRITER:
Matt Hall

ABOVE RIGHT: **This perfect-bound promotional book called *Guapo Y Fuerte (Tough and Handsome)*, an overview of Mexican wrestling, was sent to 5,000 art buyers. The vividly colored book was printed direct-to-plate in four-color process plus one solid hit of gloss varnish on every page.**

BELOW RIGHT: **Each chapter is fully illustrated, detailing both the historical and political aspects of this interesting subculture. "I really wanted to create a book to educate people about something that is very different from our culture," says Murphy. "Mexico is a rich resource for inspiration."**

CLIENT:
Consolidated Papers Inc. is
promoting its premium printing
paper called Reflections Silk.

FIRM:
Jennifer Sterling Design

ART DIRECTOR/DESIGNER:
Jennifer Sterling

TYPE DESIGN:
Jennifer Sterling

PRODUCTION:
Clare Rhinelander

PHOTOGRAPHER:
John Casado

COPYWRITER:
David Ewing Duncan

ABOVE: **Designed to read horizontally
like a calendar, this paper
promotion is based on the
concept of time. Models are
conceptually dressed like biblical
figures in a variety of materials
to convey how various textures
and details can be reproduced
on a coated sheet.**

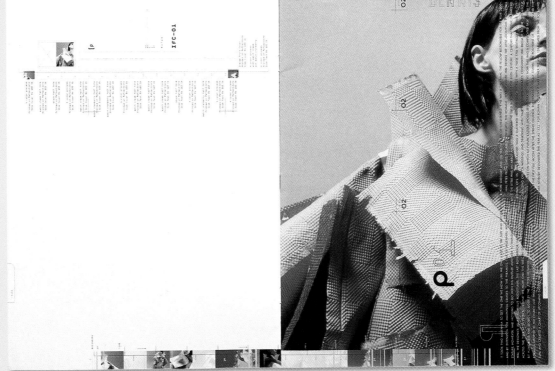

ABOVE AND RIGHT: The back panel flips out to show the production specifications for each spread throughout the calendar. Crop marks, dates, key words, and page numbers are carried throughout to aid in the pacing of the piece.

mulvanny/G2

CLIENT:
Mulvanny/G2 is an architectural
design firm.

FIRM:
Hornall Anderson Design Works

ART DIRECTOR:
Katha Dalton

DESIGNERS:
Jana Nishi and Hillary Radbill

PHOTOGRAPHER:
Fred Housel and
stock photography

COPYWRITER:
Suky Hutton

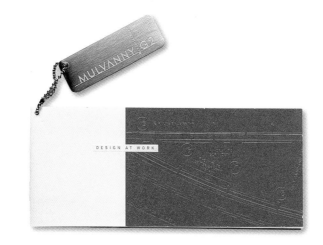

ABOVE: **Embossed on the cover is
the schematic design of
Mulvanny/G2's new corporate
headquarters. The attached
stainless-steel tag, etched in an
acid bath process, boldly portrays
their logo.**

Architecturally Moving

After 30 years in business and a relocation of their
corporate headquarters, Mulvanny/G2 wanted to reposition
themselves in the marketplace. To launch their new
identity, celebrate their thirtieth anniversary, and show
off their newly designed building, Mulvanny/G2 needed
a multipurpose brochure with distinction, character, and
elegance. "They wanted this piece to be a celebration
of their architectural design skills and to raise some
eyebrows," notes art director Katha Dalton. "But we
really didn't want it to be about what they have built.
We wanted it to be a celebration of the aspiration. This
brochure had to do lot of things in a really small package."

After a brainstorming session between the design team
and copywriter, the concept of moving was born.
"Moving can mean a lot of things," adds Dalton. "We
decided to play off the idea and show what it meant to
be moved emotionally by something as well as what it
meant to move something to a new place." With a desire
to create an interactive piece, the first round of comps
resulted in a pop-up brochure with die-cut windows

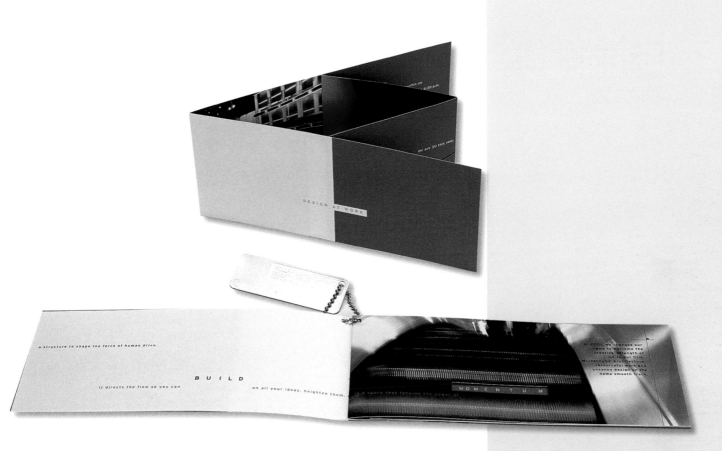

that you could look through and view the new space. The client liked the idea, but not for the brochure. So a special open house invitation was created in addition to the launch brochure. Under the redesign, the brochure maintained the die-cut windows and adopted foldout pages, poetic text, and mostly abstract imagery. "The placement of the die-cuts was a real challenge. It took a lot of back and forth between designer and copywriter to make it work," recalls Dalton. "There was also considerable discussion on how literal the images should be. We really pushed for something more metaphorical." The key line *Design at Work* was used to actively show that architecture puts design to work for people. "It's hardworking and functional," adds Dalton. Broadly targeting current and potential clients, trade people, developers, and property managers, the brochure and invitation were sent in a nicely designed envelope.

What Works

This interactive and tactile brochure created quite a stir in the architectural design arena. The die-cut windows, foldout pages, etched steel tag, poetic text, and metaphorical imagery all worked together to reposition Mulvanny/G2 as a different kind of architectural firm— forward-thinking and innovative. "The response was great, and their perception in the marketplace was uplifted," shares Dalton. "The client is getting a lot of good meetings, and the party that they held to celebrate the new launch and the new building was a mob scene."

ABOVE: On each spread of the brochure, stair-stepped type graphically combined with visuals and various die-cuts work together to get the message across. On the three-dimensional pop-up invitation, you can view the newly designed corporate headquarters in an interesting and interactive way.

meridian technology marketing

CLIENT:
Meridian Technology Marketing
is an innovative consulting firm
for technology companies in need
of marketing services and expertise.

FIRM:
Kirsten Schultz Design

ART DIRECTOR/DESIGNER:
Kirsten Schultz

ILLUSTRATOR:
Patrick Corrigan

COPYWRITER:
Kim Sarkisian

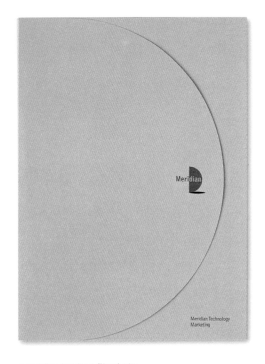

ABOVE: The brochure fits nicely
into a die-cut pocket folder. The
overall message, *a little birdie told
me*, is communicated right in the
beginning with a bird whispering
into the ear of a prospective
client.

Sharing Trade Secrets

Meridian Technology Marketing wanted to develop a
corporate brochure that would expand their market and
reposition them as a high-level strategic marketing
group. "They wanted a fresh look—something cutting
edge and interesting to look at," recalls art director
Kirsten Schultz. Wanting something that would set
Meridian apart from their competition, both the client
and designer knew that illustration was the avenue of
choice. "With illustration, we had a real opportunity to
do something unique," admits Schultz. "Photography
just felt too ordinary."

The visually driven brochure was a truly creative collab-
oration between designer and illustrator. "The artist and
I got together and brainstormed—trying to think of
visuals that would impact the way someone felt about
Meridian," recalls Schultz. "The client wanted people to
understand that they were the ones that knew all of the
trade secrets and that they had lots of different ways of
thinking and approaching a problem." To illustrate the

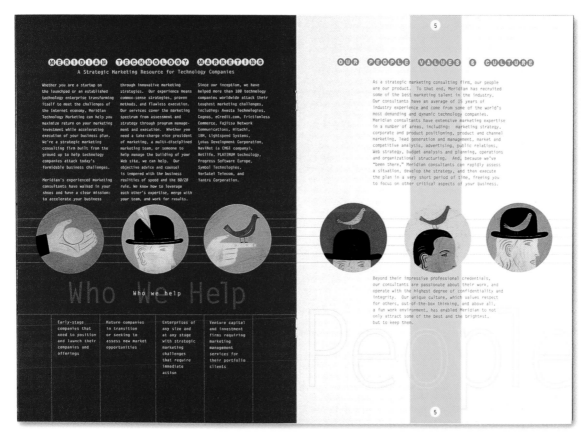

LEFT: Each interior spread conveys a different key point. This particular spread illustrates the many different ways of thinking that Meridian Technology Marketing will explore in approaching a problem.

message, a series of mixed media illustrations were created based on the idea of *a little birdie told me.* Throughout the brochure, various birds appear in different scenarios to visually carry the message along. "My goal was to make sure that we had a concept that was clearly understood," adds Schultz. Interesting and insightful quotes from customers and well-known personages, like Charles Darwin and William Blake, were also added to help support the overall concept. The muted color scheme was developed from the palette used in the highly textural paintings that appear throughout. Various lines and grid patterns, along with interesting column structures, helped to add interest and movement to the piece. "I wanted it to have a continuous flow. But at the same time, I also wanted someone to read and understand the copy." The illustrated corporate brochure was made to fit into a die-cut pocket folder along with various case studies and press release information generated by the client.

What Works

Through effective visual storytelling, the corporate brochure was able to deliver a powerful message about the unique approach that Meridian Technology Marketing takes with its clients. The illustrative approach helped to create distinction and set the innovative consulting firm apart from its competition. "It was well received by both the sales force and prospective clients," notes Schultz. "The company felt like the brochure conveyed their new message in a unique and fresh way."

abc west michigan auto auction

CLIENT:
ABC West Michigan Auto Auction
is one of eight automobile auction sites across the country.

FIRM:
BBK Studio

CREATIVE DIRECTOR:
Sharon Oleniczak

DESIGNER:
Michele Shartier

PHOTOGRAPHER:
Andy Terzes

COPYWRITER:
Randy Braaksma

ABOVE AND OPPOSITE: A saddle-stitched overview brochure, several inserts, a business card, and a CD-ROM about the company are all housed inside a white $^1/8$-inch (3 mm) gusseted, double-scored pocket folder. The duotone insert sheets can be used interchangeably to address different audiences, and a rubber stamp is used to apply updated figures to each insert.

Interchangeably Dynamic

ABC West Michigan Auto Auction was looking to increase their auction sales in the fleet leasing and dealer markets. "Even though ABC is a large company, they pride themselves on personal service and being down-to-earth and friendly, and we tried to express that in the brochure," recalls creative director Sharon Oleniczak. "Prior to this piece, ABC West Michigan Auto Auction didn't have any promotional literature, and they were really open to experimenting and doing something very different."

The design team began by doing some competitive research and conducting interviews with the company's sales force. They also spent a lot of time at the auction to absorb the experience and to learn and document how ABC operated. "At the auction, it is just a mass of activity. There are thousands of people with several auctioneers

all going at the same time," details Oleniczak. A photographer who specializes in on-location work was assigned to shoot the auction. Each photo was later altered, cropped, and positioned to convey the feel of the auction experience. Throughout the brochure, there is movement and energy not only in the layout and images but also in the color choices and headline copy.

Because ABC West Michigan Auto Auction is constantly selling and moving cars, they needed a way to document their current sales statistics. "Because it is information that always changes, we created a rubber stamp to be used by their sales force to update their numbers when they go out and present," says Oleniczak. The rubber stamp feel was also carried onto the covers of all of the materials within the interchangeable promotional package.

What Works

The movement and energy created by the imagery and layout communicate not only a sense of intensity and excitement but also help show the company's ability to sell and move cars rather quickly. The flexible ensemble clearly explains what ABC West Michigan Auto Auction does and has significantly increased their overall sales potential. With the ability to customize and update their promotional literature as needed, the company stands one foot ahead of their competition. "Since they have had this package, it has been working really well for them," observes Oleniczak.

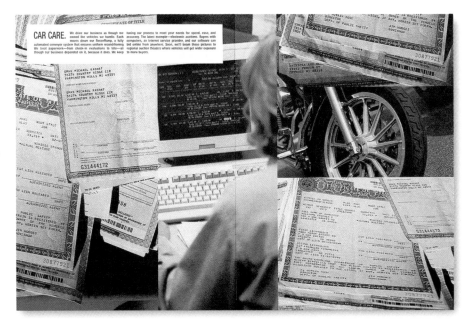

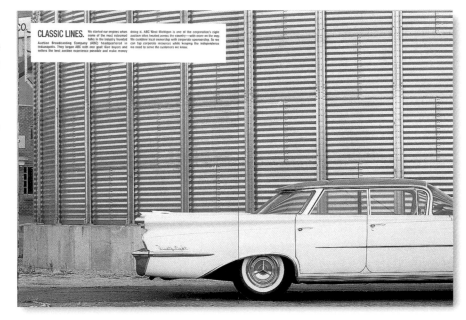

precis

CLIENT:
Precis measures communications effectiveness for media-based companies.

FIRM:
Lewis Moberly

CREATIVE DIRECTOR:
Mary Lewis

DESIGNERS:
Bryan Clark and David Jones

ILLUSTRATORS:
Bryan Clark and Steven Sayers

COPYWRITER:
Martin Firrel

ABOVE: **The embossed and foil-accented cover is made of light board and gives a sense of elegance to the piece.**

Graphic Messaging

Because the offerings of Precis were quite complex, the design firm's first task was to get a clear understanding of the company and to simplify the communication into a provocative brochure. "Most of the research was getting into the client's shoes and trying to understand what it is they do and to flush out key headlines," says designer Bryan Clark. "We learned that the service they deal with provides knowledge—informing clients how they are, how they are perceived, and the extent of their media."

Once the design firm had a direction, the challenge became how to conceptually and technically convey their idea. "We decided to develop a series of questions that would illustrate simple graphic stories about uncovering information," recalls Clark. "The before-and-after approach was used as a point of illumination. This created audience participation that endeared the reader to carry on and to look forward to the next point being made." This simple, interactive guide takes the reader, in an interesting and captivating way, through all the

key points of the company. Colored film is used throughout to reveal information and change perceptions. "The tradition goes back to children's storybooks where you open the flap and certain things appear and others disappear," observes Clark. "Precis is about uncovering new information and showing people things. The illustrations are a metaphor for discovering something new." The graphic images were initially sketched out on paper and then finalized in Adobe Illustrator. With the addition of an embossed cover, the interior spiral-bound brochure gained a more formal presentation. "We played up areas to make it look more special," notes Clark. "Initially, we looked at different things like varnishes and litho printing, but embossing was more tactile and raised the presence and feel of the brochure. It was the overture to the beginning."

What Works

By using a before-and-after approach, the brochure was able to clearly communicate, in an interactive and captivating way, key points about the company's ability to uncover new information. The engaging brochure helped to define and clarify exactly what Precis can offer their clients and how this service can impact their communications effectiveness.

ABOVE: **Each spread illustrates a key point. The colored film allows certain things to appear and to disappear—cleverly delivering the message.**

the farm inc.

CLIENT:
The Farm Inc. is a
communications design firm.

FIRM:
Soapbox Design Communications

ART DIRECTOR/DESIGNER:
Gary Beelik

DESIGNER:
Jim Ryce

PHOTOGRAPHER:
Various stock

ABOVE AND OPPOSITE: The stitched-
bound brochure fits conveniently
into a business card-size envelope.
Stickers, available in five designs,
are applied to the custom-made
envelope as an interesting graphic
accent. Trade Gothic, in mostly
lowercase, is used throughout.

Miniature Promotion

The Farm Inc. had relocated their corporate offices and
felt it was time for a change. In addition to a new identity,
they wanted a brochure, one that would be memorable
and distinctive. "In our initial research, we tried to find
different ways to interpret The Farm and what they do,"
recalls art director Gary Beelik. "We wanted the
brochure to have a strong graphic quality, something
that could take them down the road a few years and
still look current."

The designer presented several ideas to the client, but
one just resonated to the top. "It was the gut idea, and I
knew it was right," recalls Beelik. The chosen identity
consisted of five different types of architectural structures,
from silos to barns. "Originally, we had a photographer
go out and shoot Canadian farms," Beelik says. "But the
images ended up being too local." Stock photography,
because of its universal appeal and cost effectiveness,
was used instead. Using Adobe Photoshop, the designers
superimposed the company's logo onto each piece of

architecture. The iconic images were printed onto
stickers. The stickers were then applied to a blind
debossed area of custom-designed envelopes. "We
printed each sticker in a different duotone, keeping it
clean and conservative," adds Beelik. The eight-page
brochure, which fits nicely in the customized envelope,
lists all of the firm's capabilities and services. "Every
time they hand out their card, they are handing out
their brochure," notes Beelik. "It presents their image
and business in a different way—showing their creative
energy and spirit."

The biggest challenge on this project came from trying
to please another design firm. "Designing for designers
is difficult, because you are selling to communications
specialists. You have to get them to believe in the
same vision as you do," concludes Beelik. "In the end,
we were able to convince them to go with something
simple and different—drawing attention to The
Farm's unique approach."

What Works

With this attention-getting brochure, The Farm was
able to tell their company's story in a unique way. "It's
not the same old, same old," reminds Beelik. "It takes
things in a new direction." The small format and
unique distribution helped the brochure to stand out
from the crowd, giving The Farm an edge in the
marketplace.

frank clarkson

CLIENT:
Frank Clarkson is a New England–based photographer who specializes in editorial portraiture.

FIRM:
Plainspoke

ART DIRECTOR/DESIGNER:
Matt Ralph

PHOTOGRAPHER:
Frank Clarkson

COPYWRITER:
Frank Clarkson

ABOVE: The cover is letterpress printed in two colors on Gilbert Voice 80-lb. cover stock. The entire 32-page booklet is bound with a singer-sewn stitch and mailed in a two-color letterpress-printed envelope.

New England Charm

Photographer Frank Clarkson wanted a promotional piece that would attract attention from art directors by highlighting his ability to capture the unique characteristics of people and their environment on film. "I suggested that we do a little keepsake, a booklet that provides an insightful glimpse into the lives of several unique New Englanders," comments art director Matt Ralph. This 7 1/2-inch x 5-inch (19.3 cm x 12.5 cm) journalistic brochure, entitled *People I've Known*, is a collection of eight portraits and the stories behind them. "I was given several images to work with and narrowed them down," recalls Ralph. "This particular series seemed to work well together in subject matter, style, and sequencing." The handcrafted look and feel of the piece reinforced the unique photographic vision of Frank Clarkson. "I wanted to create something interesting that had a nice textural quality to it," shares Ralph. "I also wanted a bit of a contrast between the brightly colored pictures and the more traditional elements."

Each page of text is letterpress printed in black onto an uncoated and French-folded 75-lb. sheet of Luxana Canaletto. Under each caption lies a distinctive illustration. Taken from various Dover clip art books, the illustrations were scanned into the computer to create plates for the letterpress process. The photographic images, in contrast, are offset printed on an 80-lb. sheet of coated Sappi Strobe. Because this was the first time that the designer had used letterpress printing, he did a lot of preparatory research. "I went to a letterpress shop and spent a good part of the day discussing the job and learning about the process," notes Ralph. "Letterpress allowed me to create something with a real tactile and handcrafted quality."

LEFT: Each spread sets up a nice contrast between the handcrafted look of the letterpress-printed text and the sharply focused detail of the offset-printed imagery.

A series *of*
Portraits

James Bouldin
FARMER
Brunswick, Maine

James sells canned goods from "Hattie's Kitchen"
at the Brunswick Farmer's Market. Hattie is James'
wife, and her kitchen is in Bowdoinham.
James was a Commander in the Navy, and he carries
himself like a military man. What I remember about
James is his gentle voice, and the twinkle in his eye
when he told me about Hattie.

Cy Osmer
KNACKER
Taftsville, Vermont

A knacker is someone who disposes of the carcasses of dead
animals. If you're a farmer and your horse or cow dies, and you
don't know how you're going to get rid of the beast, you call a
knacker. This picture was for a Time Life book called *Odd Jobs*.
Cy lives in a trailer on a hillside just outside of Woodstock,
Vermont. He doesn't have a phone, so I left a message for him
at the country store at the bottom of his hill. I don't know if
he decided to wear the red shirt because I was coming to take
his picture, or if it was just my lucky day.

What Works

The handmade look and feel of this journalistic
brochure reinforced the personalized approach that
photographer Frank Clarkson takes in his portraiture
work. The letterpress printing and illustrated accents
makes it worth holding onto. Going after a regional
audience, Clarkson mailed the story-driven brochure to
designers and art directors in the New England area.
"He got a great response and booked several
interviews to show his portfolio," adds Ralph.

sedona corporation

CLIENT:
Sedona Corporation's customer relationship management solutions enable enterprises to identify untapped sales and marketing opportunities.

FIRM:
Kirsten Schultz Design

ART DIRECTOR/DESIGNER:
Kirsten Schultz

PHOTOGRAPHER:
Various stock

COPYWRITER:
Kim Sarkisian

ACCORDING TO A RECENT SURVEY OF 200 SENIOR EXECUTIVES AROUND THE WORLD, BY THE YEAR 2002 ROUGHLY 50 PERCENT OF COMPANIES ARE LIKELY TO BE ORGANIZED AROUND CUSTOMER TYPE, COMPARED TO 18 PERCENT TODAY. AND MORE THAN 60 PERCENT OF THE BUSINESSES REPRESENTED IN THIS SURVEY CITED "CHANGING CUSTOMER DEMOGRAPHICS AND NEEDS" AND THE "PRESSURE TO CUSTOMIZE" THEIR OFFERINGS IN LIGHT OF THESE CHANGES, AS THE MOST PROFOUND INFLUENCES ON THEIR CURRENT BUSINESS STRATEGIES.

SOURCE: ANDERSEN CONSULTING

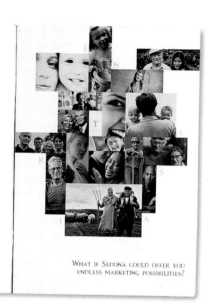

WHAT IF SEDONA COULD OFFER YOU ENDLESS MARKETING POSSIBILITIES?

ABOVE: The brochure cover is die-cut in a shape reflective of the company's logo, capturing a collage of profiles underneath. On the inside spread, a large montage of imagery reveals the diversity of demographics available with Intarsia. The color scheme incorporates the client's corporate colors, orange and blue, in a contemporary fashion.

Picturing the Possibilities

"Sedona Corporation was trying to reposition themselves from a company that sold spatial mapping software to a company that sold Internet access to a demographic marketing software," recalls art director Kirsten Schultz. Intarsia, the innovative software that is available through subscription, compiles demographic information to create a unique picture of any desired target audience. "In this brochure, they were looking for a high-level, clean, and sophisticated design that could be sent to CEOs of corporations," says Schultz. "In the design, I wanted something eye-catching that would combine both old and new elements." To carry the concept of Intarsia—which means "mosaic"—throughout the brochure, Schultz created a montage of photographs, showing the demographic breath and range that the software was capable of targeting. "I tried to pick a wide selection of different people from all around the

world," Schultz explains. "I chose them for who they were and what they were doing in the photograph." The biggest challenge, however, came from the restriction in budget. Forced to work with stock photography, the designer spent a lot of time searching for images that were fresh and different enough not to appear elsewhere in competitive literature.

To introduce each key message, the words *What If* are used along with some explanatory body copy and a carefully selected concept image. Inserted in each photograph is a partial sprinkling of the word *Intarsia*. Each image uses letters of the word to work in conjunction with the text to communicate a unique story or profile. From start to finish, the brochure unites inquisitive text with provocatively collaged imagery to show the capabilities of Intarsia as an Internet solution that brings together unique pieces of demographic information.

What Works

The mosaic design showed the demographic range while the story-driven text successfully communicated the target potential available through the innovative Internet software. "It also helped the sales force tap into a completely different target market in a sophisticated and personal way," adds Schultz.

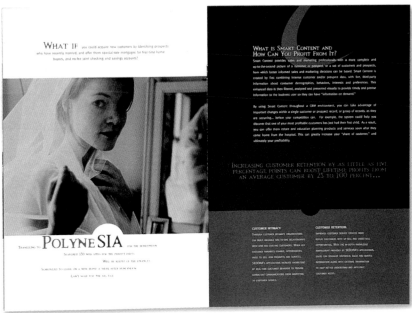

ABOVE: While the interior spreads tell the story behind the people featured, the display type, Surrogate, gives an old world quality to the company's relatively new venture.

carter richer and stark

CLIENT:
Carter Richer and Stark is a group of classically trained craftsmen specializing in stone carving and conservation masonry.

FIRM:
Soapbox Design Communications

ART DIRECTOR:
Gary Beelik

DESIGNER:
Jim Ryce

PHOTOGRAPHER:
Alison Wardman

COPYWRITER:
Brian Richer

ABOVE: **The small-format promotion piece has a sophisticated and worldly quality to it. The front cover and back panel, printed in a soft stone blue, feature a rosette-like pattern found in a book on European stone carvings. The square-flapped envelope repeats the same pattern.**

Carving Out an Identity

As a fairly new company, Carter Richer and Stark needed a way to establish themselves in the industry as highly skilled artisans. After researching the client's competition, the design team came across a stream of very slick and glossy brochures. "I really wanted to focus on the craftsmanship of their work and not the commercial aspect," says art director Gary Beelik. "Because it was going to interior designers, architects, and city planners, I wanted the piece to be modern yet traditional."

Wanting to highlight the beautifully detailed work of Carter Richer and Stark, the design team sent in a photographer to capture the carvers actively working in their creative environment. At the time, they had landed a major contract for St. James Cathedral, one of the older and more traditional-style churches in downtown Toronto. "Because they were just finishing off these pinnacles for the cathedral, we decided to feature them in the brochure," notes Beelik. Throughout the accordion-folded piece, cross-section line drawings and schematics of the project were lightly displayed in a blue-gray. "We also took found images and drawings that they had in their studio and scanned them into the computer," Beelik adds. Using Adobe Illustrator, the drawings were cleaned up and carefully placed into the layout that alternated from large to small black-and-white imagery.

CARTER RICHER AND STARK
stone carvers & conservation masons

Carter Richer & Stark is a unique company of highly skilled craftsmen specializing in stone carving and conservation masonry. Our studio combines the art of stone carving, the science of conservation and the management skills to provide an intergrated approach to projects.

For new works and restoration, our traditionally trained stonecarvers are capable of designing, drawing and executing in stone all styles of architectural ornamentation and statuary.

As conservation masons we have worked on some of the most prestigious masonry projects in North America. We have gained the respect of leading authorities in the field due to our extensive knowledge of conservation principles and practices.

At Carter Richer and Stark we are dedicated to producing the highest quality of work while completing projects within schedule and budget. Our management team have the organizational skills to ensure the success of any project.

SELECTED PROJECT LIST

St. Micheal's Cathedral *Stone Carving*	Whitney Block *Masonry Conservation*
St. James Cathedral *Pinnacle Replacement*	East Memorial Building *Stone Carving*
Canterbury Cathedral *Stone Carving*	Rochester Cathedral *Stone Carving*
Houses of Parliament *Stone Carving & Conservation*	Ontario Legislature *Masonry Conservation*
Ste. Marie Among the Hurons *Ruin Conservation*	Ottawa Senate *Entrance Carving*
The Barracks – Cobourg *Masonry Conservation*	
University of Toronto *Lettercarving*	

ABOVE: The interior panels nicely juxtapose image with text to detail the fine work of Carter Richer and Stark.

The simple two-color brochure used stochastic printing, a process that uses frequency modulation to generate randomly placed dots. Differing from the traditional dot screen, stochastic printing provides richer color with halftones that give the appearance of continuous tone. "The detail is phenomenal," shares Beelik. "Even the tinted areas look like they were printed in a solid color." The small brochure was delivered in a specially designed envelope to its target audience.

What Works

By focusing on the craftsmanship and artistry of stone carving, the eye-catching and elegant brochure not only established Carter Richer and Stark in the architectural design industry, but it also generated work in their primary area of expertise—the conservation of historic sites. Because the brochure took on a modern approach, it appealed to the client's target market—interior designers, architects, and city planners. "It got them a huge contract with the provincial government to restore the Whitney block in Toronto," concludes Beelik.

catherine macdonald & associates

CLIENT:
Catherine MacDonald & Associates specializes in garden design.

FIRM:
Thumbnail Creative Group

CREATIVE DIRECTOR:
Rik Klingle

DESIGNERS:
Valerie Turnbull and Judy Austin

PHOTOGRAPHERS:
Catherine MacDonald and various stock

Evolving Design

Garden designer Catherine MacDonald was looking for a provocative and memorable brochure that would appeal to an upscale clientele. "This was a very interesting client, a Renaissance woman. She was an artist, author, and lecturer, with garden design being her primary focus," recalls creative director Rik Klingle. "She did not want to be portrayed as a gardener. It is a higher level that she brings to a project." Prior to creating the piece, the designers spent time discussing the role of a garden designer and the artistic sensibilities that Catherine MacDonald brings to her work. "We looked at her portfolio and got to understand what her thought process was," says Klingle.

Because garden design evolves over time, the designers felt that it was important to incorporate an element of change into the design. "We wanted a structure to hold the identity together, but we also wanted flexibility for the client to customize." With this brochure, the client has the option of filling the hand-sponged boxes with anything from beautiful river rocks to bark or twigs. With an overall theme of nature's elemental diversity, several cards were designed to either be sent out individually in engraved translucent envelopes or as a series packaged in a decorative box. The purple card features metal to show structure. The ochre card portrays wind to convey the element of change, and the green card is an alum plant to represent nature's flora. "We wanted the images to go together, but each has a different focus," comments Klingle. The beautifully designed cards were letterpress-printed onto Strathmore uncoated 100-lb. cover stock, each with its own signature, specially matched color. Gray was printed on the back. "The color balance was absolutely critical. The client had a good eye for color, and she really pushed us on this," remarks Klingle. "It was a challenge."

What Works

The unique package helped to communicate Catherine MacDonald's distinctive approach to garden design. The piece's adaptability allowed the garden designer to customize and tailor each piece to the appropriate client. "After sending out the piece, she got a major contract right away," notes Klingle. "She is also getting a lot of recognition from the trade media."

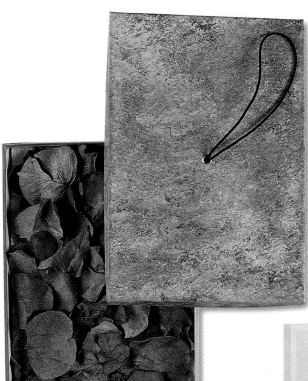

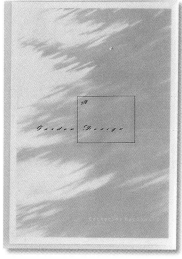

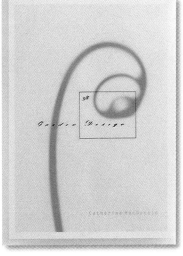

ABOVE: The versatile package rests on a bed of scented dried leaves, which gives it a natural quality. Inside the hand-sponged box is a series of three letterpress-printed cards that fits nicely into engraved translucent envelopes.

One Step Beyond

Effectively Using Color

In design, the use of color is not dictated by current trends, like in fashion or textiles, but by the communication that needs to be delivered. Color is used to call attention to certain focal points and to add support to the overall mood and message of a piece. According to Josef Albers, "Color is the most relative medium in art." And he's right. You can drastically change the overall communications of a piece by merely varying the intensity, temperature, value, or placement of color. When making decisions about color, it is important that you have the proper working environment. Neutral surroundings and color corrective lights can aid greatly when making subtle color distinctions.

When choosing a color scheme, try to vary the values—the lights and darks—instead of the hues. You will get a lot more impact that way. Having too many different colors in a piece is similar to trying to capture attention by shouting at a noisy concert. By limiting the palette, you can better control the communication that is being delivered. There has been a lot of study into the symbolic and psychological aspects of color. It is said that certain colors, by their nature, evoke certain emotions, while others have developed a symbolic or inherent meaning over time. But, because color is relative to how one uses it within a layout, these theories do not always apply for every situation. Furthermore, when picking colors, designers don't have to stick exclusively to PMS or process colors. "You can special-match things. As designers, we have to be a bit more inventive and studious in order to get our clients noticed," adds art director David Salanitro. "You can be a designer that specs things out of a catalog or you can create."

Because most inks are transparent, the color, texture, and surface of the paper you use can alter the colors you choose. "Paper has an effect on the way you will deliver a message," says art director Michael Barile. "Coated paper offers the most range of information—retaining sharpness in color and detail while uncoated paper can be a lot less controllable." Because we see color that is reflected off the surface of a paper, anything that changes the surface will affect the color that is perceived. "When experimenting with paper and color, the best thing to do is to get in touch with the paper manufacturer and request samples that show the use of various techniques on a particular sheet," notes art director Randy Smith. "A printer can also act as a great resource of information." When used effectively, color can add impact and interest to any communications device.

CLIENT:
Wausau Papers is promoting its
Astrobrights fluorescent paper line.

FIRM:
SVP Partners

ART DIRECTOR:
Randy Smith

DESIGNERS:
Randy Smith, Bob Vitale, and Jean
Page

PHOTOGRAPHER:
Various stock

COPYWRITER:
Randy Smith

ABOVE: The storytelling
brochure details the life of
the shy guy who, after using
Astrobrights, is no longer shy.
The colorful piece helps to
promote the fluorescent paper
line called Astrobrights to the
graphic design community. It
was handed out at shows and
mailed in a striking fluorescent
pink envelope.

RIGHT: Each spread shows the
versatility of the fluorescent
line of papers through the
application of a variety of inks
and production techniques.
Opaque whites are used under
the duotones to decrease the
intensity of the paper color and
make the lights pop. Foil
stamping, thermography, and
silver ink are also used
throughout. A fold-over binding
adheres several Japanese-folded
pages—giving the piece weight
and breath.

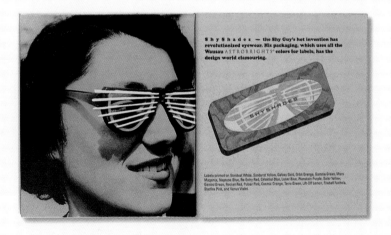

BUILD WITH METAL

ROBERTSON-CECO CORPORATION
1999 ANNUAL REPORT

CLIENT:
Robertson-Ceco Corporation makes prefabricated metal buildings.

FIRM:
Reservoir

ART DIRECTORS/DESIGNERS:
David Salanitro and Ted Bluey

PHOTOGRAPHER:
Reservoir

COPYWRITER:
Reservoir

ABOVE RIGHT: The annual report, boldly entitled *Build with Metal*, serves as a resource for builders and architects, an educational tool for investors and the financial community, and a manifesto for building with metal. A special match silver and an opaque black were both double-hit to create a smooth and solid coat. The silver was also dull varnished to give the appearance of metal.

RIGHT: Because the piece was very technical in nature, the design team tried to keep the reader interested by making each page different and exciting to look at. Each chapter emphasizes an advantage of working with metal—like strength, speed, value, flexibility, and imagination. A bold and architectural feel in the layout, type, and use of color is carried throughout.

BUILDING WITH METAL DOES NOT LIMIT YOUR CREATIVITY. METAL BUILDINGS CAN BE AS DETAILED AND AS ARCHITECTURALLY COMPLEX AS TRADITIONAL CONSTRUCTION, IF NOT MORE SO. YOU CAN BUILD ANYTHING WITH METAL.

METAL STRUCTURES ARE MORE DURABLE THAN OTHER FORMS OF CONSTRUCTION. METAL BUILDINGS CAN WITHSTAND THE HARSHEST CLIMATES IN THE WORLD. THEIR MODULARITY ALSO ENABLES METAL BUILDINGS TO BE SHIPPED AND BUILT ANYWHERE.

CREATING METAL BUILDINGS IS FAST. A METAL BUILDING CAN BE DESIGNED, ENGINEERED AND SHIPPED TO A JOB SITE IN AS FEW AS TWO WEEKS. TECHNOLOGY HAS MADE IT POSSIBLE TO BUILD ON NEARLY ANY TIME LINE.

AT ROBERTSON-CECO WE CREATE HIGHLY SOPHISTICATED, CUSTOM-ENGINEERED METAL BUILDINGS. THROUGH OUR BUILDER NETWORK, WE HAVE BUILT STRUCTURES IN PLACES AS DESOLATE AS THE ARCTIC CIRCLE AND AS POPULATED AS MANHATTAN.

WE HAVE DESIGNED EVERYTHING FROM MANUFACTURING AND WAREHOUSING FACILITIES TO SCHOOLS AND CHURCHES ON SCHEDULES AS TIGHT AS TWO WEEKS AND AS GENEROUS AS 16.

BUILD WITH STRENGTH

MATERIAL STRENGTH

CLIENT:
Etheridge is a high-end printer who works primarily with design firms and corporate in-house design and print managers.

FIRM:
BBK Studio

ART DIRECTOR:
Michael Barile

DESIGNERS:
Kelly Schwartz and Michael Barile

ILLUSTRATORS:
Allen McKinney and Michael Barile

PHOTOGRAPHERS:
Susan Carr and Gary Cialdella

COPYWRITER:
Randall Braaksma

RIGHT: This capabilities brochure is the first in a series that helps to explain, in depth, the printing process to designers. Throughout the brochure, squares of color interact with montage imagery and poetic haiku—adding a flair of artistry to the science of printing. The brochure is printed in eight colors—four-color process plus four PMS match colors on Consolidated Reflections Silk coated text and cover stock. In this particular piece, color is used to show the subtle blending and building of color available with stochastic printing.

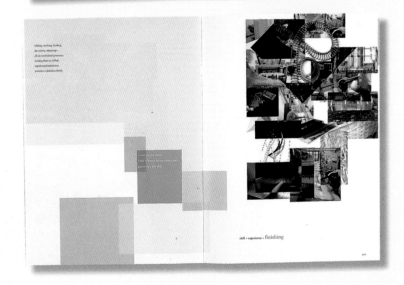

the u.s. holocaust memorial museum

CLIENT:
The U.S. Holocaust Memorial Museum is an educational resource and a living tribute to the victims of the Holocaust.

FIRM:
Plainspoke

ART DIRECTOR/DESIGNER:
Matt Ralph

PHOTOGRAPHERS:
Thomas Arledge (cover/portraits) and Timothy Hursley USHMM Archives

COPYWRITER:
Kristin Rehder

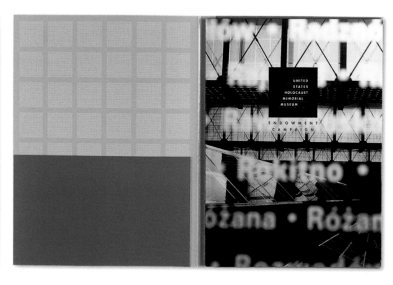

ABOVE: The logo, the pocket folder's interior grid pattern, and the brochure's cover design are all inspired by the distinctive architecture of the museum.

Remember, Remind, and Enlighten

The U.S. Holocaust Memorial Museum was launching an endowment campaign and needed a brochure that really treated their effort with an intensity that respected, yet did not sensationalize, their plight. "A lot of the museum's publications talk about the history and the lessons of the Holocaust, but not many discuss the way people use the museum," shares art director Matt Ralph. "Most people think it is simply a memorial to the victims, but it does have an important educational role." Throughout the brochure, several people were profiled using the museum in a unique way. "One of them is the chief of the Washington, D.C., Police Department," adds Ralph. "They have a great program where all of the recruits must go through the museum to learn about the misuse of power." Both art director and writer spent several days meeting with department heads, administrators, and survivors. They also went through the museum's extensive archives. "We really immersed ourselves in the museum—its mission and its people. It was really interesting," says Ralph.

LEFT: Throughout the brochure, individual profiles offer informative insight to the museum's vast resources.

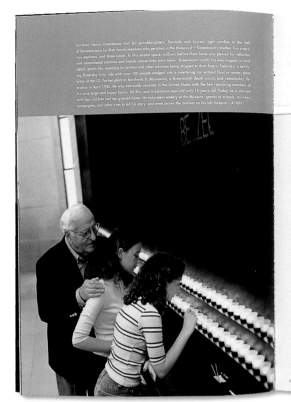

Survivor Henry Greenbaum and his granddaughters, Danielle and Lauren, light candles in the Hall of Remembrance for their family members who perished in the Holocaust—Greenbaum's mother, five sisters, two nephews, and three nieces. In this serene space, millions before them have also paused for reflection and remembered relatives and friends whose lives were taken. Greenbaum recalls his own tragedy in vivid detail: ghetto life; watching his mother and other relatives being shipped to their fate in Treblinka; a terrifying three-day train ride with over 100 people wedged into a sweltering car, without food or water; slave labor at the I.G. Farben plant at Auschwitz III (Monowitz); a three-month death march; and, remarkably, liberation in April 1945. He was eventually reunited in the United States with the few remaining members of his once large and happy family. All this, and Greenbaum was still only 18 years old. Today, he is married with four children and ten grandchildren. He volunteers weekly at the Museum; speaks at schools, churches, synagogues, and other sites to tell his story; and even shows the number on his left forearm—A18991.

HENRY GREENBAUM
Survivor and Museum volunteer

"The Museum is my haven, a memorial for my whole family. We don't have gravesites for those we lost—there is no cemetery. This is their resting place, and this is where my family and I can honor them and keep their memories alive so that they will not have died in vain. I have taught my own children to be good to one another, not to discriminate against anyone. The children are our future: teach just one, and you help to teach the whole world."

The museum's compelling architectural structure plays an important role in the look and feel of the brochure. The cover graphically portrays the impressive glass walkways of the museum, with the blurred text etched into the glass reflecting all of the towns affected by the Holocaust. "I really liked the hard-edged, industrial feel of the architecture and the way the exhibitions used shape, color, drama, and typography. I wanted to capture that in the brochure," comments Ralph. The brochure also picks up on the various observations and experiences of visitors. "The museum has kept and cataloged all of its visitor comment cards. It's an amazing collection and a great resource," explains Ralph. "At one point, I was thinking of reproducing the handwritten cards themselves, but instead I ended up using just the statements as bold and thoughtful accents throughout the piece."

What Works

By profiling several people who use the museum in a unique way, the brochure helped to highlight the institution as an important educational resource. Even in a sluggish economy, the endowment brochure was very successful in raising funds and creating awareness. The piece also helped to establish a new identity for the museum.

ontario college of art & design

CLIENT:
Ontario College of Art & Design is the oldest and most prestigious art and design college in Canada.

FIRM:
Viva Dolan

ART DIRECTOR/DESIGNER:
Frank Viva

PHOTOGRAPHER:
Ron Baxter Smith

COPYWRITER:
Doug Dolan

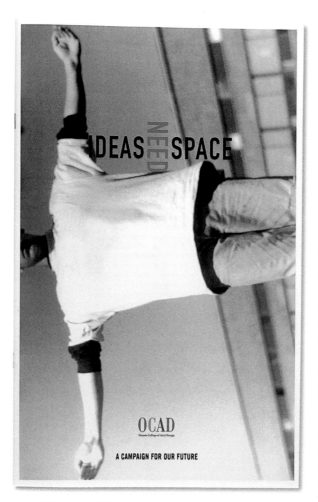

ABOVE: **The large tabloid-size cover boldly presents the concept** *Ideas Need Space.* **To convey the sense of expansion necessary, the featured image dynamically portrays a student with his arms wide open.**

Needing to Expand

Ontario College of Art & Design (OCAD) was looking for a brochure to act as a fundraising vehicle to raise capital for the construction of a new building and the renovation of the old facilities. "The last major renovation to the college happened in the early sixties," comments art director Frank Viva. "When I visited the college and walked the hallways, I realized how deteriorated it was. It occurred to me almost immediately that the best way to get across the idea that OCAD was in desperate need was to simply document the building—showing what the place was really like." After meeting with department faculty and administrators, the designer was confronted with his biggest challenge. "There are lots of different faculty at OCAD, each having separate viewpoints and perspectives on how the college should be portrayed to the world," observes Viva. "The design faculty wanted to reach out to the business community and the art faculty wanted to reach out to large art institutions and the curatorial audience." To get the faculty to unite under one theme, the designer focused not on the aesthetics and look of the piece but on the strategic concept and problem solving behind the communications device. "We ended up tying it under the slogan *Ideas Need Space,*" adds Viva. "It was the one thread that connected all of the disciplines." Taken from the perspective of the students, this tabloid-size brochure featured a journalistic approach to telling the plight of OCAD. Throughout the piece, text and image work together to highlight the college's need for funding to restore the forward-thinking institution to its role as a cultural center. To attain its financial goal, the fundraising brochure was distributed to major donors and institutions, alumni, and people identified in the community as having a connection to the college.

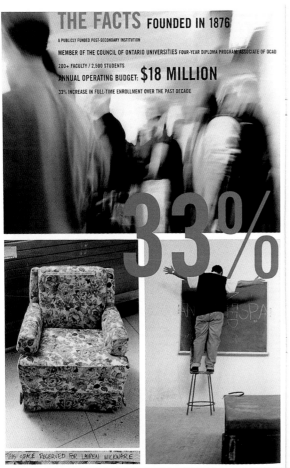

THE FACTS FOUNDED IN 1876

A PUBLICLY FUNDED POST-SECONDARY INSTITUTION

MEMBER OF THE COUNCIL OF ONTARIO UNIVERSITIES FOUR-YEAR DIPLOMA PROGRAM. ASSOCIATE OF OCAD

200+ FACULTY / 2,500 STUDENTS

ANNUAL OPERATING BUDGET: $18 MILLION

33% INCREASE IN FULL-TIME ENROLLMENT OVER THE PAST DECADE

33%

THIS SPACE RESERVED FOR LAUREN WICKWARE

CAMILLE NEEDS SPACE

THE IMPACT 14,000 ALUMNI INCLUDE MANY PROMINENT DESIGNERS AND ARTISTS. OCAD GRADUATES LEAVE THEIR IMPRINT ON CANADIAN CULTURE AND COMMERCE AS CREATIVE THINKERS, ENTREPRENEURS, VISUAL COMMUNICATORS, INVENTORS, PRODUCT DESIGNERS, CULTURAL PRODUCERS AND EDUCATORS. TRAINED AS CREATIVE THINKERS AND INNOVATIVE PROBLEM-SOLVERS. THEY ENRICH OUR LIVES AESTHETICALLY, FUNCTIONALLY AND ECONOMICALLY AS PART OF A WORLDWIDE GROWTH INDUSTRY.

INCREASE IN ENROLLMENT

LOOK AROUND

THE WORK OF OCAD ALUMNI IS EVERYWHERE, INFLUENCING THE WAY WE LIVE OUR LIVES AND SEE THE WORLD.

FOLLOWING IN THE FOOTSTEPS OF CREATIVE THINKERS AS DIVERSE AS MICHAEL SNOW AND THE GROUP OF SEVEN, OUR ALUMNI HAVE CREATED EVERYTHING FROM THE LOOK OF TORONTO'S STREETCARS TO ADIDAS RUNNING SHOES; FROM IKEA ADS TO DAVID BOWIE VIDEOS; FROM THE BLUENOSE DIME AND ONE-DOLLAR "LOONIE" TO LOGOS FOR CN, LABATT AND THE CBC, FROM PRESIDENT'S CHOICE PRODUCTS TO SIGHT AIDS FOR THE VISUALLY IMPAIRED.

LEFT: Throughout the brochure, certain words are presented in all capital letters to create a sense of urgency and to bring attention to some of the major issues. The images vary from interior shots to portraits of students tightly cropped inside a frame, playing up the concept of needing space. The corporate colors—red, green, blue, and yellow ochre—are carried throughout.

What Works

The brochure's bold use of text and image called attention to the college's urgent need for funding while the personalized approach helped to please OCAD's diverse faculty and student body. The overall design was so compelling that it caught the attention of donors, raising the money that the institution so desperately needed. Because of the success of the brochure, the college has established an ongoing relationship with the design firm to work collaboratively to generate other collateral material.

the massachusetts college of art

CLIENT:
The Massachusetts College of Art
is an art institution that offers a
variety of both undergraduate
and graduate programs.

FIRM:
Stoltze Design

ART DIRECTOR:
Clifford Stoltze

DESIGNERS:
Tammy Dotson and Cynthia Patten

PHOTOGRAPHERS:
Ilan Jacobsohn, Michael Mulno,
Susan Byrne, and Heath
Photography

COPYWRITER:
Rebecca Saunders

ABOVE: The die-cut cover features
an unfolding box that reveals the
various artistic disciplines. The
view book is sent to prospective
students in a specially designed
envelope that carries both the
organic and geometric elements
that appear throughout the book.

Thinking Outside the Box

For years, the Massachusetts College of Art has produced
a complete and extensive catalog for their institution,
including everything from a background on the school to
course offerings. This year was different. With the
Internet becoming more and more popular, the college
decided to use their website as the primary source for
information. This decision changed the role and scope of
the catalog, making it more of a visual view book, focusing
on the philosophy and artistic diversity of the school.
"One of the things that we did with this project was to
develop an overall concept," says designer Tammy
Dotson. "We thought about the process of learning and
how all of the various disciplines start with the basic
geometry of form and shape." With a spatial approach in
mind, the interior graphics and layout, as well as the corner
die-cuts, all became metaphors for thinking outside of
the box. "The book can be seen as a dimensional object,
and when you open it, different aspects of the school and

the various departments unfold," adds Dotson. The view book breaks up into three major sections—the introduction, the areas of study, and the graduate program.

Within the art college, there are eight disciplines in which to study. Each discipline is introduced with a montage of student artwork, giving the piece tremendous visual impact and personalization. "On each spread, there is a detailed section of a student's work that is used as a large background, and then we repeated the image full frame somewhere else on the page," Dotson explains. Each area of study is coded with a graphic icon that is prominently displayed on the cover and repeated within the specialization. "Representing a different department, each one specifically links up to the website," notes art director Clifford Stoltze. "There is a lot of continuity between the design of the site and the view book."

What Works

Designed to inspire a diverse range of potential students, the brochure creates a nice balance between the structural disciplines and the more expressive ones. Because the book is conceptual in nature, it appealed to the creative and inquisitive mind of an art school student. This highly functional and visually interesting view book was mailed to high school guidance counselors and prospective applicants. "The joint effort between the view book and the website has made a significant increase in the number of applicants," acknowledges Stoltze.

ABOVE: **Each discipline visually opens with a montage of student artwork. The fluid linework adds an organic, handmade quality to the overall graphic and geometric design.**

the council of europe

CLIENT:
The Council of Europe is an intergovernmental organization that aims to protect human rights, promote awareness of and encourage cultural diversity, seek solutions to problems facing the European society, and help consolidate democratic stability.

FIRM:
Diefenbach Elkins Davis Baron

ART DIRECTOR/DESIGNER:
Wladimir Marnich

PHOTOGRAPHER:
Magnum Photos

COPYWRITERS:
Lothar Hertwig, Renee Gautron, and Estelle Steiner

ABOVE: From cover to cover, type has been enlarged, reduced, and manipulated to create interest and flow. Shown is the French version, the first book created and used as a design template for the other five in the series.

What We Do

The Council of Europe has an important role to play in the advancement of human rights and the maintenance of democratic stability in the greater European area. Because of the complexity and combination of things in which the council is involved, there is a lot of public confusion and misinterpretation. "A lot of people are not really sure about what the Council of Europe does," explains art director and designer Wladimir Marnich. "With this brochure, the council wanted to explain the different things that they do." To express the purpose and importance of the Council of Europe, the designer chose to take on an artistic approach, quite contrary to most literature put out by the organization, to highlight certain works taken on by the council. "Most of the work the council does is information oriented," notes Marnich. "I decided to do something different by presenting a highly visual and typographic style."

A series of six books, entitled *Europe Under a Single Roof 1949-1999*, was created, each in a different language. Because each book needed to be created in a different language, it was a challenge to maintain an overall design consistency throughout. In the French language, for instance, the words are much shorter and obviously different to look at than the same words translated in German. But, despite the design and technical challenges, the designer was able to make all six books have the same look and feel. "I spent a lot of time just looking at type and talking with people that spoke each language," recalls Marnich. "I wanted to make sure that when you opened the same page, it would not change a lot from book to book." On every spread, type has been enlarged, reduced, and manipulated to create interest and flow. From chapter to chapter, type and image work together to expressively convey the outstanding achievements and milestones made by the Council of Europe. Magnum Photo, who carries the work of internationally recognized photographers, donated the photography and the Council of Europe supplied all translations for the main text and accent quotes.

LEFT: Each book is divided into five main chapters—"Human Rights and Fundamental Freedoms," "Democracy," "Diversity," "The Rule of Law," and "Social Cohesion."

LEFT: Each chapter seamlessly links conceptual imagery with inspirational quotes, enticing the viewer to read on.

NI DANS LE CŒUR DES
INDIVIDUS NI DANS LES MŒURS
DE LA SOCIÉTÉ, IL N'Y AURA DE PAIX
TANT QUE LA MORT NE SERA PAS MISE
HORS LA LOI *Albert Camus*

What Works

Given to heads of state, ambassadors, politicians, and decision makers, each book helped to clearly outline the purpose and importance of the Council of Europe in an interesting and captivating way. The typographic treatments that are carried throughout each book are not only artistically stunning but quite engaging, inspiring the viewer to read the body copy and begin to understand the scope and workings of the council. "The book is a tribute to the advancement of democracy, human rights, and the rule of law in Europe," adds Daniel Tarschys, Secretary General of the Council of Europe. Most of the books were given away at the council's fiftieth-anniversary celebration. Those who could not attend, received books in the mail.

the university of technology, sydney

CLIENT:
The University of Technology, Sydney is an educational institution in Australia.

FIRM:
Emery Vincent Design

ART DIRECTOR/DESIGNER:
Emery Vincent Design

MANAGING DIRECTOR:
Penny Bowring

PHOTOGRAPHER:
Sandy Nicholson

COPYWRITER:
Supplied by client

ABOVE: **The catalog and pocket folder graphically work together to capture the attention of a youthful audience.**

Trend Setting

The University of Technology, Sydney (UTS) was looking for a career and course guide that would have a strong visual impact in the education marketplace. Positioning the university as cool, hip, and slightly alternative helped to attract graduating high school students to the not-so-traditional school. "The piece is directed at the youth market and needed to be appealing and effective," notes managing director Penny Bowring. "The imagery has abstract qualities that reference popular culture graphics. The use of unconventional type and the haphazard placement of elements is designed to appeal to the rebellious nature of the target market." In addition to being visually appealing, the piece also had to communicate the university's wide range of studies in a clear and easily accessible manner. "The overall impression is that it is a highly professional organization that also looks cool," says Bowring. "The landscape format and the use of the structured table and grid provides for maximum information in an easy-to-read format."

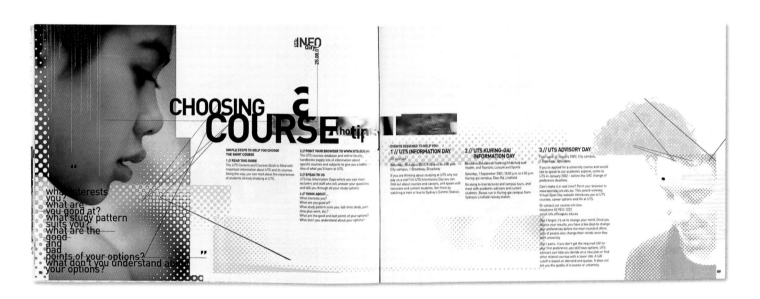

A photographer was commissioned to visit several campuses, shooting a broad range of students from various disciplines. "The goal was to capture the vibrancy of real-life situations at UTS," adds Bowring. Throughout the catalog, intersecting lines, type, and a dot-pattern grid overlap photography in an interesting and dynamic way. "The layering of imagery evokes how students learn and discover throughout the course of their studies," details Bowring. "The screen creates a dynamic counterpoint to the clear, sharp photography, setting up an interesting tension. The intersecting lines represent the potential directions that the students can take in their studies." Distributed to graduating high school students, the catalog fits nicely inside a pocket folder, along with other necessary enrollment information generated by the university.

What Works

By using unconventional type and graphics in an easy-to-read format, the brochure helped to attract the trend-conscious youth market. With its dynamic and appealing design, it has not only significantly increased enrollment, but has also established a trend for more innovative educational catalog design in the Australian market. "It has produced real returns for the university," claims Bowring. "Some rival universities are currently pursuing similar design approaches."

ABOVE: Intersecting lines, type, and a dot-pattern grid overlap photography to communicate the learning process that exists within a flexible curriculum. The screen effect is also printed as a varnish—adding an interesting surface texture to the already visually exciting page.

compugen

CLIENT:
Compugen is a pioneer in the field of predictive life science achieved through the convergence of molecular biology and advanced computational technologies.

FIRM:
Jason & Jason Visual Communications

CREATIVE DIRECTOR:
Jonathan Jason

DESIGNER:
Meirav Tal-Arazi

PHOTOGRAPHER:
Yoram Reshef and various stock

COPYWRITER:
Audrey Gerber

ABOVE: The intriguing and graphic marketing package symbolically combines both the human and mathematical aspects of the company. Throughout the piece, strings of genetic information are seamlessly combined with symbolic lifestyle imagery to convey the overall message.

The Human Touch

Compugen wanted to re-brand and position themselves as a company that merged computational technologies with molecular biology and medicine. "They were well known in the industry for being able to decipher genetic information," notes creative director Jonathan Jason. "But they wanted to be positioned as being more biology focused and less computational, because they felt that it would put them more in touch with their market. In order to position them this way, we had to come up with an image that combined the two."

The biggest challenge for the design team was how to effectively communicate the highly complex company. "We were asked to make their technology easy to understand," recalls Jason. "We spent a lot of time researching—sitting with them for weeks, learning about the biology and the technology aspects. We viewed their labs, interviewed people, and researched all of their competition." Because the company's offerings were more sophisticated, the design team chose to use metaphorical images to describe in a simple way what Compugen's products do. On the cover of the promotional package, various hands were used to show the combining of different disciplines to form a new discipline. "It's an analogy of math and life science that works together to provide solutions," notes Jason. "The hands bring in the human side of what they do." Throughout the piece, strings of genetic information were combined with symbolic lifestyle imagery to convey Compugen's commitment to raising the duration and quality of life by advancing drug discovery and development. The overall marketing package consists of a company profile brochure, two product brochures, three product data sheets, and a corporate annual report.

ABOVE AND LEFT: **Inside the pocket folder is a company profile brochure, two product brochures, three product data sheets, and a corporate annual report. The laminated pocket folder is printed in four-color process plus metallic ink. The die-cut slots house both a mini CD-ROM and a standard CD-ROM.**

What Works

By using symbolic imagery and clear text, the design team was able to successfully communicate Compugen's complex story and new corporate image— positioning the company as a leader in the field of predictive life science. "Jason & Jason created a clear and distinctive new look for the company," adds Tsipi Haitovsky of Compugen. "All of the materials were very well received, both within the company and by our target audiences—investors, media, customers, and those in the scientific community."

integralia foundation

CLIENT:
Integralia Foundation trains physically disabled people for the workforce.

FIRM:
Summa

CREATIVE DIRECTOR:
Josep Maria Mir

ART DIRECTOR/DESIGNER:
Wladimir Marnich

ILLUSTRATOR:
Mariscal

PHOTOGRAPHER:
Archived images

COPYWRITERS:
Sergi Nebot

ABOVE: The Spanish word *discapac-itados,* meaning "disabled," has been divided into two words. By separating the word, the design team is able to focus the attention on the word *able,* thus delivering the message of the piece. The laminated brochure is wrapped with a bellyband.

More Than Able

The Integralia Foundation wanted a brochure that they could distribute to donors and corporate sponsors that detailed their organization and its mission. Given out at the opening night and the launch of this new venture, the brochure served as a gift and an expression of thanks for ongoing support. "We thought it would be nice to do a book that portrayed disabled people that have been able to go beyond their disabilities to become famous," recalls art director Wladimir Marnich. "We sat down and discussed various people who were famous and disabled. After that, it was a matter of going through the list and doing the research. Once we had a selection of images, we also had to find out if we could use them. It was a challenge." With only two weeks to complete the job, the design team was limited in the scope of content that they could put into the book. "There were a lot of people left out either because of copyright issues or the lack of quality imagery available." To compensate, the cover was doubled up, and the interior pages were printed on a heavy stock to add weight and substance to the piece.

Throughout the small booklet, various well-known personalities are portrayed. From painters to presidents, each personage helps to convey the message that disabled people are able, working, and highly functional individuals. "The word *discapacitados* is one word in Spanish, and what we tried to do was to break it up into two. We wanted to take the 'able' away from the 'dis,' making the disabled able," notes Marnich. The word was then transformed to *dis-capacitados* to call attention to the message of the brochure—individuals who are more than able to integrate into the workforce.

What Works

By using recognized personalities as examples of what can be achieved by men and women with disabilities, the brochure was able to communicate the potential impact that the foundation could have on the lives of many, in a clean and elegant package. It also brought comfort to all donors and supporters to see that their monies were going to a good cause.

ABOVE: As you flip through the brochure, you encounter numerous nationally and internationally recognized personalities who have all overcome their disabilities. From political figures to renowned artists, each individual helps to remind us of the potential that people with disabilities have. Although the brochure was printed in five colors, it was mostly monochromatic in tone.

sts synergy

CLIENT:
STS Synergy is an innovative
and expanding company that
offers complete healthcare
services to both NHS trusts and
private hospitals.

FIRM:
Diefenbach Elkins Davis Baron

ART DIRECTOR/DESIGNER:
Wladimir Marnich

ILLUSTRATOR:
Jeff Fisher

COPYWRITER:
James Melvin

ABOVE: **Because all of the products
that STS Synergy delivers are
wrapped in paper and sealed with
a label, the designer thought
that it would be appropriate to
incorporate that element into the
design. The cover, crisp and clean,
is sealed with a label that has to
be broken to open the brochure.
The entire piece is printed on an
uncoated, bright white stock.**

Taking Another Approach

STS Synergy needed to set themselves apart from the competition to stake their claim in the healthcare services industry. "Because they are not the only company of this type in the UK, we wanted to approach things from a different point of view," says art director Wladimir Marnich." After viewing literature from several competitors, the design team saw a way to create distinction for the company. "We found that many other companies used a lot of photography of large pieces of equipment in their brochures to show what they could do," notes Marnich. "We thought it was a really cold approach and advised our client against it. Instead, we wanted to break away from what everyone else was doing to appeal more to the human side of the company." Capitalizing on the opportunity to be different, the design team chose to create a piece that was less technical in approach and more personal and inviting.

The biggest hurdle was coming up with a brochure that would actually make it into the hands of the decision makers. "Because the people who would first receive the brochure were not the ones who actually did the contracting, we had to be captivating in that first contact stage. If it did not get through the first level, it would never get to the people that really mattered," explains Marnich. "It was a combination of making the piece really attractive and keeping the text simple. We needed to get across in two lines what the company was all about." By making the text easy to read, the illustrations interesting and intriguing, and the layout inviting, the brochure was able to effectively communicate all of the key points while creating interest and distinction for the up-and-coming company.

our mission

Maintain our position as the UK's most dynamic and creative Healthcare Services group by offering an unrivalled service, excellent value for money and products of the highest quality.

Run our business with consideration for our employees and encourage them to strive for excellence, develop themselves and care for our customers.

Value co-operation above all else because it is only by working together that we can achieve these objectives.

3

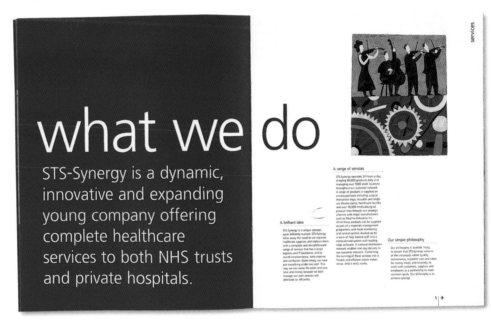

what we do

STS-Synergy is a dynamic, innovative and expanding young company offering complete healthcare services to both NHS trusts and private hospitals.

A range of services

STS-Synergy operates 24 hours a day, shipping 80,000 products daily and managing over 5500 stock locations throughout our customer network. A range of products is supplied on a managed basis including surgical instrument trays, reusable and single use theatre packs, healthcare laundry and over 16,000 medical/surgical product lines through our strategic alliances with major manufacturers such as Medline Industries Inc. All of these products can be supplied as part of a materials management programme with local monitoring and central control, backed up by a team of fully trained staff and a computerised system with leading edge software. A national distribution network enables next day delivery to our customer network. Combining the running of these services into a flexible and efficient whole makes sense. And it really works.

A brilliant idea

STS-Synergy is a unique concept, quite brilliantly realised. STS-Synergy takes away the need to use separate healthcare suppliers and replaces them with a complete and straightforward range of services that has a single logistics and IT backbone, and so avoids inconveniences, extra expense and confusion. Quite simply, we have put everything under one roof. This way we can make life easier and save time and money because we both manage our own services and distribute so efficiently.

Our simple philosophy

Our philosophy is twofold: firstly, to ensure that STS-Synergy remains at the crossroads where quality, convenience, customer care and value for money meet; and secondly, to work with customers, suppliers and employees as a partnership to meet common goals. Our philosophy is to achieve synergy.

5

What Works

The brochure's inviting nature and intriguing illustrations and text communicated all of the company's key messages in a clear and interesting way. By choosing to take a more personal approach rather than a technical one, which is quite typical in the healthcare services industry, the brochure was able to break through existing barriers and land in the hands of decision makers. "Before it gets to the buying department, a brochure must go through a secretary or first-level nurse," observes Marnich. "This brochure made it through to the group of people that we were aiming at."

ABOVE: Each spread is presented in a dynamic fashion. The color scheme plays up the blue corporate color, the column structures are asymmetrical, and the page density alternates from left to right—all adding interest and flow to the piece. The hand-painted illustrations, mostly conceptual in nature, bring out the human aspect of the company.

the abraham lincoln presidential library and museum foundation

CLIENT:
The Abraham Lincoln Presidential Library and Museum Foundation is raising funds to construct a world-class destination for scholars and the public alike.

FIRM:
Stan Gellman Graphic Design, Inc.

CREATIVE DIRECTOR:
Jim Gobberdiel, Jim Gobberdiel Communications

ART DIRECTOR:
Barry Tilson

DESIGNERS:
Barry Tilson and Michael Donovan

ILLUSTRATORS:
BRC Imagination Arts Inc. and Art Associates Inc. (architectural)

FONT DESIGN:
Tom Carnase

COPYWRITER:
John Fundator

ABOVE: The small-format brochure is produced with a four-page cover that is doubled over and pasted to give it strength and stability. A title seal is both blind embossed and debossed on Fraser Passport 80-lb. cover stock to add texture and presidential appeal to the piece.

Promoting a Legacy

The Abraham Lincoln Presidential Library and Museum project was in need of funding. To approach potential donors, a brochure was created to excite and provide information about the new endeavor that was to be erected in downtown Springfield, Illinois. "The total funding needed for the museum and library is $115 million," shares creative director Jim Gobberdiel. "It's an opportunity for corporate sponsors to be connected with a project of this caliber. It will also give everyone an opportunity to have a real look at Lincoln's life and legacy." Because the project was a massive undertaking, it was important that the brochure communicate a sense of confidence that the endeavor would indeed be completed. "The quality and content of the brochure needed to convince people that this is a doable objective," adds Gobberdiel. "The brochure needed to solidify the idea that the project is really going to happen." The distinguished-looking design has several unique touches— a blind embossed and debossed title seal on the cover, a custom-designed font called Illinois Palatino, and various storytelling illustrations.

The historic-looking brochure commences with an overview of the project and the universal appeal of Lincoln. It continues by highlighting the economic benefits such a project would bring to the state of Illinois and the scholarly potential it would offer the world. "There has been no central museum to convey and expand upon the legacy of Abraham Lincoln," notes Gobberdiel. "Within the brochure, we discuss the three major components of the project—the museum, the library, and the tourism center. From there, we talk about all of the facilities and exhibitions and the multitude of programs." The brochure concludes with various funding options. Inserts, located in the back pocket, are used as a cost-effective way to present items that would change over time, like schedules and naming opportunities.

What Works

In addition to capturing the look and feel of the Lincoln era in a clean and sophisticated format, the fundraising brochure was able to communicate the importance of preserving the legacy of the former president. The overall quality and strength of the content helped corporations feel confident about donating money to this new venture in Illinois.

ABOVE: The interior pages discuss the overall theme, *Expanding the Legacy*. To give the piece a historic look, each spread is printed on natural Nekoosa Solutions 100-lb. text stock in four-color process plus two PMS colors. The insert sheets are designed to be separate as a cost-effective way to update information without having to reprint the entire brochure.

brown medical school

CLIENT:
Brown Medical School is part of Brown University in Providence, Rhode Island.

FIRM:
Plainspoke

ART DIRECTOR/DESIGNER:
Matt Ralph

PHOTOGRAPHER:
Len Rubenstein

COPYWRITER:
David Treadwell

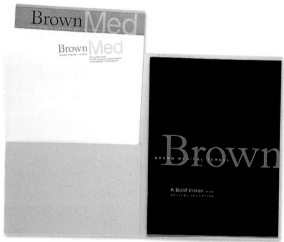

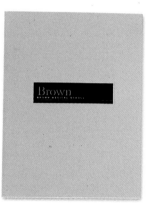

ABOVE: The customizable brochure includes cover letter stationery, proposal stationery, and a series of cards, which fit conveniently in the back pocket, detailing various aspects of the school.

Contemporary View on Tradition

With an increase in competition for both students and funding, Brown Medical School was looking for distinction. They wanted a bold, contemporary feel to their promotional material that still respected the traditions of the university. "The real trick was to balance the two sensibilities without going too far either way," recalls art director Matt Ralph. "This piece also had to be flexible. They wanted it to help them with fundraising, but they also wanted it for other things, like student recruitment and public relations."

To begin the project, research was conducted in the form of interviews. "The writer and I spent a day at the school, meeting with administrators, faculty members, and department chairs and sitting in on a couple of classes," says Ralph. After getting a full understanding of the institution and its students, an editorial approach was set in motion. "In our research, Dr. Anthony Caldamone came to our attention. He is a practicing surgeon who had graduated from the school and now teaches there. We wanted to do a feature and created this center gatefold around him." This day-in-the-life profile captures Dr. Caldamone's commitment to his practice and his patients.

To make the brochure interesting, various other visual approaches were explored. "We looked at a lot of different locations—identifying the people, where they were, and what they were all about," notes Ralph. "Rather than being a shoot that was structured and art directed, I really wanted a spontaneous, authentic storytelling feel. Going with a journalistic approach, we could achieve that." Throughout the brochure, quotes and stories capture the reader's interest with bold and compelling imagery. Designed as a complete package, this multipurpose brochure can be customized in various ways to fit any desired purpose.

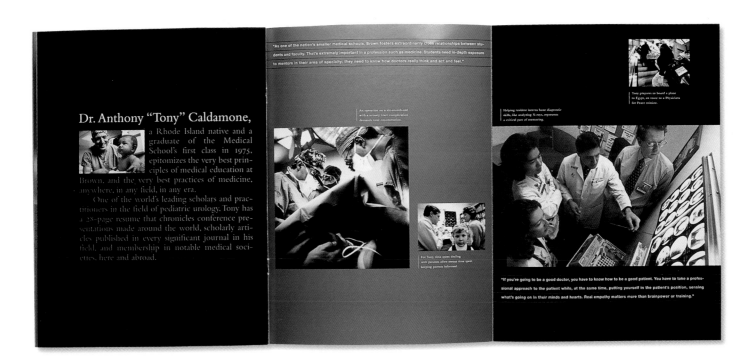

Dr. Anthony "Tony" Caldamone,

a Rhode Island native and a graduate of the Medical School's first class in 1975, epitomizes the very best principles of medical education at Brown, and the very best practices of medicine, anywhere, in any field, in any era.

One of the world's leading scholars and practitioners in the field of pediatric urology, Tony has a 28-page resume that chronicles conference presentations made around the world, scholarly articles published in every significant journal in his field, and membership in notable medical societies, here and abroad.

"As one of the nation's smaller medical schools, Brown fosters extraordinarily close relationships between students and faculty. That's extremely important in a profession such as medicine. Students need in-depth exposure to mentors in their area of specialty; they need to know how doctors really think and act and feel."

An operation on a six-month-old with a urinary tract complication demands total concentration.

For Tony, time spent dealing with patients often means time spent keeping parents informed.

Helping resident interns hone diagnostic skills, like analyzing X-rays, represents a critical part of mentoring.

Tony prepares to board a plane to Egypt, en route to a Physicians for Peace mission.

"If you're going to be a good doctor, you have to know how to be a good patient. You have to take a professional approach to the patient while, at the same time, putting yourself in the patient's position, sensing what's going on in their minds and hearts. Real empathy matters more than brainpower or training."

What Works

This story-driven brochure uses text and image not only to engage the reader but also to highlight the unique characteristics of the school—the distinguished faculty, the liberal medical education, the dynamic research enterprise, and the network of teaching hospitals. "It was successful in that it galvanized their efforts and gave them a tangible piece that they could give to people to tell them about what they were doing," offers Ralph. "In the past, they relied a lot on things they generated themselves. This gave them a professional package that really helped them get people's attention."

ABOVE: In the center gatefold, an inspirational story unfolds. The large photos, printed in a bronze and black duotone, were a challenge. Time had to be built into the project to properly test the sequencing and placement of the ink to get just the right effect. Spot gloss varnish is also used to achieve a nice contrast with the matte finish paper.

One Step Beyond

How Limited Budgets Can Enhance Creativity

Working within a tight budget does not necessarily mean a restriction on creativity. In fact, it can often enhance creative output. Such is the case with Lewis Moberly's annual report for NABS. "We wanted to create something that was interactive, dynamic, and interesting enough that someone in the communications industry would want to read it," details designer Paul Cilia La Corte. "Because the audience was so visual, the piece needed to be something that was unexpected, where the viewer was never quite sure what the next bit was going to do." The bold use of black and white helped to clearly communicate the organization's integrity, while the vibrant burnt orange displayed warmth and energy. The economical color scheme not only kept printing costs to a minimum, but it also allowed for flexibility. "With this annual report, everything had to work very hard. If something went into the piece, it did so with good reason," says Cilia La Corte. "Working with a tight budget, in a way, helped, because it forced us to do things that we may not have otherwise tried. With limitations comes creativity. The more focused you are, the stronger the idea and the communications will be." In a powerful and cost-effective manner, the interactive communications piece took the traditional components of an annual report and reinvented them for the highly visual audience of NABS.

Limitations in budget do not always result in the economic use of production and printing techniques. Sometimes, the project or client can be interesting enough that it attracts attention from vendors and other creatives who are eager to participate pro bono. For instance, PEN Canada, a charitable organization that champions the rights of writers, is a good example of a client that is not only intriguing but also open and respectful of personal vision and interpretation. PEN Canada's annual report, an interesting assignment with full creative freedom, sparked interest from a variety of talent and resources. "As soon as I knew that we were going to be working on their annual report, I started talking to people—warming them up to the idea and what PEN Canada was all about," recalls art director Gary Beelik of Soapbox Design Communications. "I made a lot of personal calls, relying heavily on my relationships with vendors." A full-color comp was produced to show off the concept and entice participation. Because of the strength of the idea, all illustration, photography, and paper were donated, and the printing was done at cost. For a mere $2,000 (Canadian), 25,000 pieces were produced. "It takes a lot of work and a lot of dedicated people to get the project done right," says Beelik. "We all pitched in to get a piece that we were really happy with." When an interesting project comes along, it provides an opportunity to work collaboratively with others to create something outstanding, even when the budget is restrictive. In addition to highlighting the work and talent of all involved, it stimulates creative energy, growth, and renewal. "It's an opportunity to do something inspirational and fun," concludes Beelik. "At the end of the day, that is what is all about anyway."

CLIENT:

PEN Canada is a nonprofit organization that works on behalf of imprisoned poets, essayists, and novelists to secure their freedom.

FIRM:
Soapbox Design Communications

ART DIRECTOR/DESIGNER:
Gary Beelik

ILLUSTRATOR:
Paul Dallas

PHOTOGRAPHER:
James Reid

ABOVE: This editorial-style annual report is designed like an old world novel, featuring 10 true-life stories written by members, imprisoned writers, and prominent Canadian authors, like Margaret Atwood. Each handpicked story offers insight and a unique perspective. The cover, printed in full color with an overall matte varnish, was made from a scanned piece of chipboard. To give the piece a worldly quality, elements were debossed and embossed into the cover. A deboss was also applied to the type, creating a letterpress look. The faux stamp, reproduced in four-color, gives the appearance of a hand-applied sticker.

RIGHT: The designer worked closely with the printer to determine the size and maximum number of pages. Because the book was to be perfect-bound, they were not obligated to imposition the pages in any specific order. To get the feel of a full-color report on a mostly two-color job, the printer ran three forms—two of them in black plus one PMS color and the third in four-color. The process color sheets were then dispersed throughout the report to give it visual depth and interest.

CLIENT:
NABS is a charitable organization
that provides a wide range of
services for people in the communi-
cations industry at every stage
of their working life and into
retirement.

FIRM:
Lewis Moberly

ART DIRECTOR:
Mary Lewis

DESIGNER:
Paul Cilia La Corte

COPYWRITERS:
Paul Cilia La Corte and Janet Hull

RIGHT AND BELOW: **The introduction
piece, vibrantly printed in burnt
orange, unfolds the numerous
resources and programs that
NASBS has to offer someone
throughout their career in the
communications industry. Each
section is housed inside an easily
removable folder.**

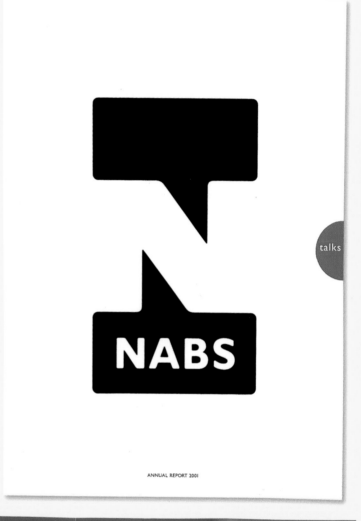

ANNUAL REPORT 2001

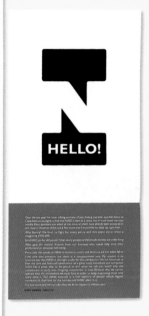

ABOVE AND LEFT: **Various sections, printed economically in black, dynamically outline the benefits of being a member or supporter of NABS.** *Hello!* **details a message from the director.** *Bullmore and Reay* **continue the conversation, and lastly,** *Many Thanks* **shows all the people who have contributed throughout the year. Each interactive section, appropriate for a visually literate audience, either flips up, down, or over or unfolds to reveal its message. The package concludes with the financial report.**

murphy design inc.

CLIENT:
Murphy Design Inc. is a marketing and communications company focusing on creative business strategies.

FIRM:
Murphy Design Inc.

ART DIRECTOR/DESIGNER:
Mark Murphy

ILLUSTRATORS:
Melinda Beck, Cathie Bleck, Calef Brown, Amy Butler, David Butler, Christian Clayton, Rob Clayton, Cyclone, Gerald Dubois, Barry Fitzgerald, Chris Gall, Jordin Isip, Jim Fish, Hole in the Sky, Tim Hussey, Philippe Lardy, Joel Nakamura, Curtis Parker, Alain Pilon, Charlene Potts, Marc Rosenthal, Mark Ryden, Michael Schwab, Joe Sorren, James Steinberg, Gary Taxali, Cathleen Toelke, Greg Tucker, Mark Ulriksen, Nicholas Wiltin, and James Yang

ABOVE: The cover is produced in a six-color process plus a metallic ink. The graphics are a combination of sketchbook marks and textures scanned in and manipulated. The word *future* is copied, scanned, and bitmapped. A spot gloss varnish is also applied to the cover in an interesting abstract pattern.

Millennium Fever

This group self-promotional calendar derives its theme from the mystique of the new millennium. "We were going from 1999 to 2000, and some people had a warm and friendly feeling about it and others did not," notes art director Mark Murphy. "Everyone had his or her own interpretation of what the new era would bring. It was also a theme that anybody, regardless of age or appreciation of art, could understand." Murphy worked cooperatively with a printing company, two paper companies, a bindery company, and various illustrators to create a promotional piece that would be interesting enough to generate work for everyone involved. "A brochure that is a mere collection of your work is becoming a passé idea. You have to do projects that inspire and entertain your clients. The typical capabilities piece sprinkled with nice images is no longer enough. The brochure has to represent a feeling or a message of who you are," claims Murphy. "I've done this type of promotion for the last six years. It is always a premier collection of top-level talent in printing, paper, art, and design."

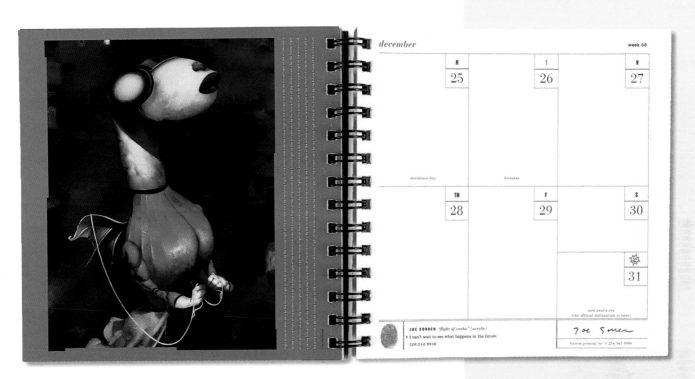

With so many people involved, coordination and organization was key. "There were a lot of details to contend with, and there was also a great deal of trust among everyone involved," says Murphy. "You have to promote your vision with the other participants—selling them on the passion of what the project is all about. But when you work with good people, a great product will come out of it." Each illustrator was given a creative brief detailing the overall theme, specifications, and deadline. The final interpretation was up to the artist. The designer waited until all of the artwork came in before he assembled the book. Creating a consistent flow from one page to the next, Murphy added in the text, calendar pages, and art. The final book was produced direct-to-plate with no film work involved.

What Works

"A lot of people who receive these every year keep them, and it's growing in interest every year," shares Murphy. "It has been a very successful venture, and people just resonate to it." Targeted to art buyers, this yearly self-promotional calendar also functions as a valuable resource book.

ABOVE: United under one theme, each artist shares his or her interpretation of the future. Each piece of art runs as a full bleed on a coated sheet, juxtaposed against the calendar pages, which are run on a combination of two different uncoated sheets.

plainspoke

CLIENT:
Plainspoke is a graphic design
firm that specializes in educational
and cultural work.

FIRM:
Plainspoke

ART DIRECTOR/DESIGNER:
Matt Ralph

PHOTOGRAPHER:
Brian Wilder

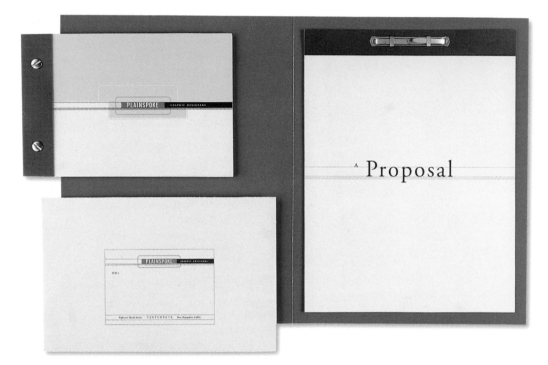

ABOVE: The piece is fashioned to
have the feeling of an old ledger.
The semiwraparound cover not
only conveniently hides the spine,
but also adds to the overall
dimensional quality of the piece.
It is sent out in a matching
envelope, along with a proposal
folder, when necessary.

Thinking about Flexibility

This flexible and easy-to-update promotional brochure
gives prospective clients a glimpse into the strategic
thinking behind the design work of Plainspoke. "I wanted
to have a little compact portfolio presentation that we
could send out to clients," art director Matt Ralph
remarks. "We had been sending samples out, but it got
to be cumbersome. It just made sense to try and corral
some of our best work together in one piece."

The most challenging aspect of the brochure was
developing the descriptive text for each project. "To
distill our creative thinking behind a project into a little
paragraph was difficult but important for the client to
see," notes Ralph. "We always try to really think about
each project and what it communicates. I wanted people
to have background knowledge about the work we do,
rather than just showing a bunch of pictures." The art
director also worked very closely with the photographer
to make sure that the composition on each shot was just

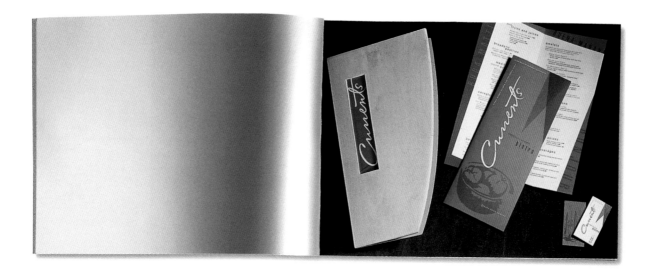

right—varying the images from full bleed shots to more traditionally cropped views. "In the pacing, I wanted to break up the sequencing a bit," explains Ralph. "It was just too repetitive to have everything looking all the same." The text also alternates in placement from front to back.

Two sets of inserts were printed, drilled, trimmed, and stored in sections. Because the pages are loose and not permanently bound, the design firm can customize a brochure to fit any prospective target audience. "We can skew it more towards identity or publication projects. It gives us a lot of freedom and flexibility," adds Ralph. The handy and compact brochure can be easily taken apart by disassembling the Chicago screws, which are usually used on horse bridals. Silver is used as an accent color throughout, tying the screws into the overall color scheme.

What Works

By providing prospective clients with a glimpse into the strategic thinking behind each project, the design team was able to highlight their ability to effectively communicate ideas in a visual way—making the brochure much more than a mere portfolio presentation. Designing the pages to be interchangeable made the promotional brochure extremely useful in the firm's marketing efforts. According to Ralph, "It has generated many more projects for us."

ABOVE: **Each presentation page is printed in six colors—four-color process, silver, and light gray. Spot varnish is also used on Potlatch McCoy matte finish 65-lb. cover stock.**

joel nakamura paintings & illustrations

CLIENT:
Joel Nakamura is an illustrator
and fine artist working in
Santa Fe, New Mexico.

FIRM:
Joel Nakamura
Paintings & Illustrations

ART DIRECTOR:
Joel Nakamura

DESIGNER:
Greg Hally, Hally O'Toole Design

ILLUSTRATOR:
Joel Nakamura

ABOVE: The handsome brochure
contains Nakamura's well-known
mythological and spiritual illus-
trations. Each piece is subtly
identified on a small sheet, which
can be flipped back and forth on
the spiral binding. The highly
textural cover features the
artist's logo, and the solid pages
highlight the images and show off
the patterns that appear within
Nakamura's work.

Spiritual Icons

Illustrator Joel Nakamura needed a way to introduce a
new style to his repertoire of work while still maintaining
the promotion of his signature style that he had become
well-known for doing. "I wanted a promotion that
showed different projects and would function in two
ways—one, as a vehicle for prospecting illustration
clients; and two, as catalog for collectors who buy paintings,"
shares Nakamura. The biggest challenge for the artist
was trying to edit his vast collection of work into a
cohesive yet diverse sampling. "Making the right
selections was important," notes Nakamura. "I wanted
to show work that would be interesting to a variety of
clients, from record companies and corporations to
galleries. I also wanted to show my ability to think
and solve problems."

To capture a new and unexplored audience, Nakamura created an interesting package that highlighted his new creative endeavors. "It is what I call my primitive work. It's about line, color, and pattern—more distilled down than my illustration work. A lot of people respond to it, and it has allowed me to venture into different areas," says Nakamura. "Because it's interactive, it was a great way to debut a different wrinkle to what I do." The slide promotion, although complex, was quite easy for Nakamura to produce. "I went to an ad specialty company. They printed the viewer, duped the slides, printed the stickers, and put everything together in a box," he shares. The artist finds that advertising specialty catalogs are a great way to get ideas for interesting promotions, especially ones not typically seen in the illustration or fine arts industries. "It's the kind of promotion that someone is going to get curious about sooner or later, and they are not going to throw it away," Nakamura adds. To maintain market presence in his signature style, a brochure was also created to beautifully display Nakamura's mythological and spiritual illustrations.

What Works

The promotional duo not only helped the artist to maintain his current market presence but also opened doors for a new body of work to flourish. Because the slide viewer was such a novel item, it captured the attention of buyers, who held onto the promotional piece for just the right assignment. "So many illustration promotions go into the round file, the trash can. I feel pretty good that about 95% of the time, people have kept these promotions and shared them with other designers," says Nakamura. "Both the catalog and slide box have brought in a lot of work for me." The promotion ended up in the hands of the Olympic Organizing Committee—landing work for the artist with the 2002 Winter Games in Salt Lake City. "If you can put good things out there, they will always pay off down the road," he concludes.

ABOVE AND LEFT: The customized promotional package contains a viewer, slides of the artist's new primitive work, and a business card. It is flexible enough to be sent as a self-mailer or as part of another promotion.

ove design & communications

CLIENT:
Ove Design & Communications is
a branding and strategic design
firm.

FIRM:
Ove Design & Communications

CREATIVE DIRECTORS:
John Furneaux and Michel Viau

DESIGNER:
Grant Cvitkovich

PHOTOGRAPHER:
David Graham White

COPYWRITER:
Rachael Bell

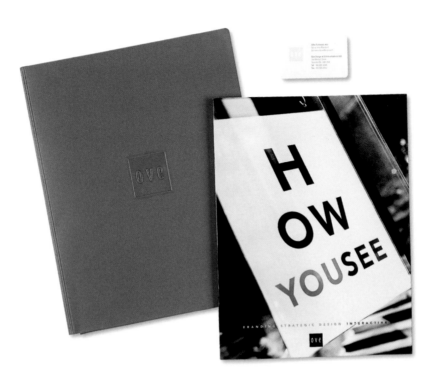

ABOVE: The brochure is housed
inside an embossed pocket folder.
In the back sits a business card
and ID-ROM, which contains a 45-
second QuickTime movie of the
firm's portfolio of work.

Perception vs. Reality

Ove Design & Communications wanted to put together a promotional piece that would show the strategic thinking behind the work they do. "In a corporate world, good design is not necessarily self-explanatory. There is a lot of thinking and planning that goes on behind the pieces we produce," says creative director John Furneaux. "In this brochure, we wanted to create something that would provide a balance between the strategy and the execution without being crowded by design tricks and techniques. We wanted to say that our approach is not about making pretty pictures. It is about thinking and turning those thoughts into actions."

The biggest challenge for the design team was coming to a consensus on the brochure's key points and choosing the best pieces to illustrate such points. After doing both formal and informal research with their clients, as well as looking at what their competition was producing, the design team came up with their strategic plan of attack. "We looked at a number of brochures that were either very text heavy or were just picture books," recalls Furneaux. "We know that people faced with a large amount of copy do not always read it. But if you can break up the copy into sections, they are more likely to look at the whole thing. We decided to put the text into the images so the reader would at least read the pictures and come away with our point of view." Using the eye test concept, the design team was able to carry the key phrase *How You See* throughout the piece. The large-format brochure is divided into four sections—Branding and Identity, Investor Relations, Interactive Media, and Packaging and Environments. Within each section, a diverse range of clients and markets, from large blue-chip financial companies to small high-tech start-up companies, is represented.

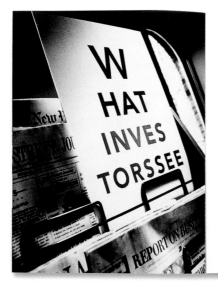

Investor Relations

Investors see differently. They want the big picture and the bottom line. Clear. Fast. Credible. Answer the questions before they're asked. Online, in print, in the media. It's a precise skill. Ove can help you translate strategy into compelling themes that get attention, combined with the details prudent investors demand.

LEFT: Each area of expertise is broken down into sections. Beginning with an introductory spread, printed in silver and black, each area details the firm's strategic approach. Following is a full-color presentation of work within each area of specialization. The duotone spreads help to keep the reader's attention focused on the message, while the colored pages help the clients' work to stand out. The overall brochure is saddlestitched, allowing the spreads to lie flat as the reader turns each page.

What Works

Focusing on Ove's unique approach to communications, the large-format brochure established credibility and distinction for the Canadian branding firm. By placing text into key images, the brochure made it virtually impossible for the viewer to walk away without getting the firm's overall message. "We use it as a door opener. The piece has been very successful in getting us on the long and short list to bid on projects," concludes Furneaux. The call-to-action brochure also served as a template for the firm's slideshow presentation that is given when soliciting new clientele.

stoltze design

CLIENT:
Stoltze Design, a graphic design firm specializing in corporate, advertising, institutional, and publishing, worked collaboratively with various illustrators and musicians.

FIRM:
Stoltze Design

ART DIRECTOR/DESIGNER:
Clifford Stoltze

ILLUSTRATORS:
William Tisdale, David Miller, James Kraus, Melinda Beck, Jordin Isip, Calef Brown, John Weber, Joseph Hasenauer, Vida Russell, Frank Kozik, Nancy Jo Haselbacher, David Scott Sinclair, Jay Bernasconi, Cynthia von Buhler, Polly Becker, Dmitry Gurevich, Juliette Borda, Katherine Streeter, Resa Blatman, David Pohl, Bina Altera, and Bob Maloney

ABOVE AND OPPOSITE: The CD promotional package is printed in three colors—black, purple, and opaque white. In contrast, the inserts are printed in four-color with an overall varnish. The fonts used throughout are Distillation, Johndvl, Subluxation, and Calvinohand.

Multifaceted Promotion

There's nothing like a group endeavor to get the creative juices flowing. Working collaboratively not only jump-starts the creative process, it also divides up the time and expense of doing a promotion. Such is the case with this multifaceted promotional package.

Each illustrator was given a song to listen to, the dimensions in which to work, and the creative freedom to interpret the music in their own voice. The finished artwork ranged from traditional drawing and painting to alternative collage and assemblage. "We chose the illustrators to be fairly diverse, like the music," states art director Clifford Stoltze. While the artists were busy creating, Stoltze worked on the packaging. "I did a paper sleeve instead of a standard jewel case," he notes. "I wanted to use a muted and off-beat color, and the grayscale was a nice effect with the paper." The interlocking pocket conveniently holds the illustrated inserts in place while still allowing them to be seen. "I wanted the packaging to act as a portfolio for the postcards," says Stoltze. "Yet, I didn't want it to compete with the four-color artwork." The cover features the work of William Tisdale printed on kraft board using three colors—black, purple, and opaque white. The various inserts were contrastingly printed on coated paper with an overall varnish.

Because of the complexity of the project, coordination, organization, and the minimization of costs were a challenge. "We tried to get the best printing prices possible. The insert sheets were done to maximize the press sheet, and the separations were donated. We also saved a lot of money by collating, assembling, and folding all of the packages ourselves," notes Stoltze. "But the real payback is knowing that you had a hand in the creation of this interesting object," shares Stoltze. "It is only through doing these types of projects that I was able to break into designing music packaging."

What Works

The creative collaboration between several illustrators, musicians, and a design firm was not only successful in getting each collaborator work in the music industry, but it also help to raise money for the William Tisdale memorial trust fund. "A lot of us had positive feedback about getting calls as a result of this promotion," acknowledges Stoltze. "On the local Boston college radio stations, the CD got a lot of airplay and actually made the top 10." Limited-edition posters were also created out of the insert press sheet.

belyea

CLIENT:
Belyea, a graphic design firm, ColorGraphics, a printer, and Rep Art, an illustration and photography group, all worked together to produce a self-promotion piece.

FIRM:
Belyea

CREATIVE DIRECTOR:
Patricia Belyea

DESIGNERS:
Anne Dougherty, Ron Lars Hansen, Naomi Murphy, and Kelli Lewis

ILLUSTRATORS:
Charles Bell, Jeff Burgess, Elizabeth Simpson, James Lorincz, Mark Heine, John Bolesky, Steve Hepburn, Michael McKinnell, Gavin Orpen, Lorne Carnes, Gregg Eligh, Glenn Mielke, Kelly Brooks, Kathryn Shoemaker, Michael Knox, Barbara Klunder, and Sharon Smith

PHOTOGRAPHERS:
Storme, Tony Redpath, and Lesley Burke

COPYWRITERS:
Liz Holland and various other creatives

ABOVE: The linework that wraps the cover is made of the word *brainstorm*, where the letterforms have been broken apart and graphically reconstructed to form a new image. When you open the piece, you are faced with a die-cut window of color and shape—a sneak peak to some of the graphic interpretative images within.

Inspiring Words

When a design firm, an illustration and photography firm, and a printer collaborate to create something that speaks to the soul, the results are nothing shy of inspirational and uplifting to all involved. "We wanted to create a piece that people would use and be inspired by," says art director Anne Dougherty. "Our hope is that the pages are not left blank. You can write in it or draw in it. There are no limitations." Creative director Patricia Belyea adds, "A project like this is fueled by passion. It allows people to move in a way that they could not have otherwise, and from that you get everyone giving their finest."

To produce the collaborative self-promotion brochure, various creatives—from painters and sculptors to actors, musicians, and poets—were contacted to write an inspirational quote. "We searched for people who gave the Northwest the flavor that it has," recalls Belyea. "A big part of the project was making the requests and waiting for the information to come back to us. Out of the 150 people that were contacted, we received back 49 quotes to work with." Once the quotes came in, they were sent to the artists at Rep Art. "We asked them to respond to whatever quote they wanted," notes Belyea. "The remarkable thing was that no two chose the same quote. That meant that each person was pretty moved by their quote and could see a way to illustrate it." Throughout the journalistic brochure, inspirational quotes are complemented by an illustration or photograph. When you turn the page, there is an interpretative graphic that combines both the visual qualities of the illustration with a key word from the quote. "If you flip through the book one way, you see all of these very intriguing illustrations. If you flip through it the other way, you get a very different feel to the whole book," concludes Belyea.

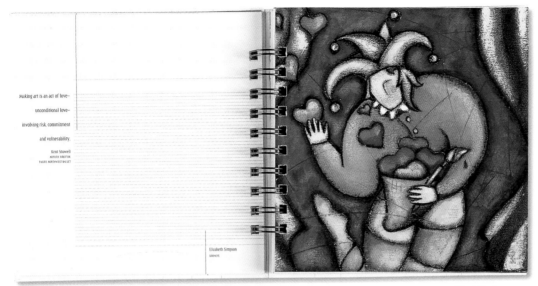

LEFT: **Each spread boasts an inspirational quote that is complemented by an illustration or photograph. When you turn the French-folded page, there is an interpretative graphic to reinforce the key message of each quote.**

Making art is an act of love—
unconditional love—
involving risk, commitment
and vulnerability.

Kent Stowell
ARTISTIC DIRECTOR
PACIFIC NORTHWEST BALLET

Elizabeth Simpson

unconditional

What Works

Brainstorm explores the creative process through the words and images of many collaborators as an attempt to inspire others. The promotional piece was well received not only by clients but by all who participated in its creation. "This piece gave us the opportunity to go on a creative journey and express ourselves," says Belyea. "It also adds to the overall understanding of Belyea as being a very different kind of company." Working collaboratively is also a cost-effective way in which to share expenses and distribute the workload, allowing each contributor to take advantage of a top-notch promotion.

skidmore inc.

CLIENT:
Skidmore Inc. is a full-service design and commercial art studio.

FIRM:
Skidmore Inc.

ART DIRECTORS:
Julie Pincus, Mae Skidmore, and Sue Levytsky

DESIGNERS:
Julie Pincus, John Latin, Robert Nixon, and Laura Lybeer-Hilpert

ILLUSTRATORS:
Gary Cooley, Bob Nixon, Steve Magsig, Ann Redner, Scott Olds, Dave O'Connell, Rob Burman, Toni Button, Jeff Rauf, Larry Dodge, Chuck Gillies, Rudy Laslo, Bob Andrews, John Ball, Wayne Appleton, George Burgos, Carrie Russell, and Ron Alexander

PHOTOGRAPHERS:
Rocki Pedersen and Jeff Hargis

COPYWRITERS:
Mae Skidmore and Sue Levytsky

ABOVE: **Created to have an old-fashioned notebook-like feel, the promotional brochure is bound with cloth tape and rivets and accented with a punched label. Focusing on the design process and the various offerings of Skidmore, the piece was distributed in a specially designed envelope that features various little doodles about thinking.**

Changing Perceptions

Because Skidmore began as a commercial art studio in Detroit doing mostly automotive illustration and design, they have been pigeonholed into that market. Since their beginnings in 1959, they have expanded into other areas and needed to communicate that to a more diverse audience. "Because we have been in business for so long, there is a stigma. The great thing is that people look to you for stability. What is not so great is that you don't necessarily get a lot of breaks for being cutting edge," remarks art director Mae Skidmore. "With this brochure, we were trying to counteract some of the impressions that clients had about us." In addition to their design and illustration work, Skidmore also offers web development, retouching and imaging, and marketing services.

Wanting to break into the corporate market, the design team realized that its biggest challenge was determining their strategic plan of attack. "Traditionally, we only called upon advertising agencies. But in the last five years, we have been making a real push to deal directly with Fortune 500 companies," adds Skidmore. "Because we were going after a new area, we really had to spend a lot of time thinking about who we were, what we did, and how we could leverage that to a corporate market. Putting the brochure together was easy once we figured all that stuff out." The design team came up with a promotional brochure that highlighted all of the firm's creative and marketing services in an interesting and captivating way. "We didn't want to do a brochure that said the same thing as everyone else," recalls Skidmore. "We really wanted to get out of that rhetoric and really express the personality of the company."

THE DESIGN PROCESS

RIGHT: The brochure is broken down into four major sections that detail the creative process and highlight the firm's offerings.

RIGHT: An envelope in the back of the brochure houses several portfolio samples.

What Works

With their brochure's interesting use of production techniques, illustration, photography, and type, Skidmore Inc. was able to break away from their traditionally accepted role and appear much more cutting edge. By highlighting the design firm's creative abilities and full-service approach, the brochure was able to attract attention from corporate clients outside the automotive industry. "With this piece, we got work almost immediately. Everyone we gave it to was so impressed," shares Skidmore. "The brochure was not only creatively rewarding but also great for image building and increasing company revenues."

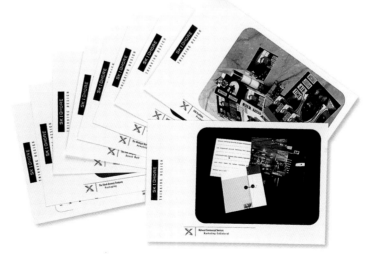

samatamason

CLIENT:
SamataMason is a graphic design firm that has expertise across all media.

FIRM:
SamataMason

ART DIRECTORS:
Greg Samata and Dave Mason

DESIGNERS:
Kevin Kreuger, Greg Samata, and Dave Mason

Investors are
looking for direction.

Stocks rally, bonds slip
before Greenspan
Reuters Business News: Monday February 12, 2001 6:54 pm

Blue chips end
solidly higher
Business Week Online: Monday March 26, 2001

ABOVE: Directed towards the investor relations community, the promotional brochure addresses the confusion and frustration in today's economic climate. To set the scene, various viewpoints from a diverse group of media are presented. Contradictory in nature, each quote helps to support the need for direction by a firm with expertise and experience.

Direction and Expertise

SamataMason wanted to put out a promotional brochure directed towards the investor relations community—addressing current problems in the marketplace. "There is a lot frustration out there. People are not sure what to do, what to say, and how far to go," comments art director Greg Samata. "Many companies aren't even doing annual reports in the traditional way anymore." Focusing on corporate annual reports, the brochure gives insight, direction, and successful examples of the firm's proven track record. "We have 25 years of experience doing annual reports for almost every major industry, companies from Fortune 50 on down to nonprofits," adds Samata. "With this brochure, we were trying to say that we can help companies navigate their way through the economic climate."

Everyone is talking to your shareholders.

If you've got something to say to them, we can help you say it well.

Why?
Because this is what drives us, what we were built for.

Julia Levy, Ph.D., D.Sc., FRSC, President and Chief Executive Officer
QLT Inc.
2000 Annual Report

The promotional brochure begins by setting the tone of the marketplace using varied and somewhat contradictive viewpoints. "The front part is our way of saying that everybody is confused," explains Samata. "You listen to one commentator who says the market is thriving, then you listen to another and he says we are in the tank." To obtain a comprehensive list of various statistical commentaries, the design team searched all media. The chosen quotes were then printed on top of subtly displayed imagery of the inner corporate environment. After setting the scene, the brochure displays the design firm's current portfolio of annual reports. Each begins with a silver header page, which is printed on a translucent sheet. Following each header is a visual glimpse into the design and overall strategy behind each report. "We photographed certain parts that we thought would have some interest. It was more about the overall idea than showing every detail of the book," notes Samata. "We really wanted to show that there was a message behind each one." Quotes from CEOs and other key management people also reinforced the overall message. The piece closes with the firm's philosophy and an impressive client list.

What Works

The clear, honest, and direct communications behind this promotional piece hit home with many companies looking for solutions. The firm's assessment of the economy and overall marketplace, accompanied by their vast and diverse expertise in the area of investor relations, was a strong sell. "We have developed new business because of this piece," concludes Samata. "A lot of people really liked what we had to say. The brochure was successful on a number of levels." Produced just before the September 11 disaster, the book was not distributed until after—making the piece extremely timely as many companies were facing economic troubles.

ABOVE: The majority of the book shows the design firm's current portfolio of annual report work. Silver header pages, printed on translucent sheets, reveal each annual report underneath. The photography and text work together to highlight the design and overall strategy behind each featured annual report.

magma

CLIENT:
Magma is a graphic design firm
specializing in corporate design.

FIRM:
Magma

ART DIRECTORS:
Lars Harmsen and Ulrich Weiss

DESIGNERS:
Sandra Angstein, Ralf Christe,
Patrick Grossien, Isabelle
Gontgen, Boris Kahl, Sabine
Klein, Verena Mildenberger,
and Chris Steurer

PHOTOGRAPHERS:
Christian Ernst and Magma staff

COPYWRITER:
Rieke Harmsen

ABOVE: The symbolic cover image,
printed in four-color process plus
green, represents the book's overall
theme—the breaking and rebuilding
of traditions and conventions. The
top half is printed with a gloss
varnish while the bottom half is
left alone to reflect the title pages
that are half black and half white.

On the Edge

Magma wanted a way in which to spark creativity within
their design team. "We wanted to do a project that we could
all work on. It was an opportunity to experience new things
that we may not have on a client project," says art director
Lars Harmsen. "We really wanted to create a new vision
and to push further with our work."

Am Rande, which translates in English to *On the Edge,* is the
result of creative collaboration between several designers.
Each chapter explores a different theme. Most are socially
critical in nature, while others deal with design issues. "We
found that there are a lot of themes that really interest us
that have nothing to do with our usual work," notes
Harmsen." As graphic designers, we have something to say,
and we love to interest ourselves in reading and editorial
content." Within the book, there are 12 chapters, each
exploring something that is on the edge. For instance in
chapter six, "On the Edge of Truth," the design team invented

LEFT: Chapter three, "On the Edge of the Woods," takes a mystical approach and balances the intrigue of the woods with the fear of being in the wild. Imagery, text, and graphics work together to deliver the message.

a story about the creation of Magma, while chapter five, deals with experimental typography that pushes or is on the edge of legibility—a play on what is legible and what is not. Each chapter, printed in black and white for consistency, is quite visually and contextually different than the next. The cover portrays a symbolic image that represents the book's overall theme. "It is about the breaking of traditions and conventions and rebuilding them again with something new," offers Harmsen. "With this project, we tried to stop working on client projects to free our minds and build something new." This piece is quite different from the usual promotional literature that the company puts out. "It is not so important to show the work that you have done as it is to create or invent something new," concludes Harmsen. "We hope that the input from this project will flow over to our more commercial projects."

What Works

With its diversity in context and imagery, the piece was able to push the existing boundaries of the design firm, revealing a newfound energy and creative potential. "The more you do graphic design work, the more it starts to become routine. You know what the client wants to see and then you make it for them," remarks Harmsen. "A project like this opens the mind again for new ideas and new ways of working."

The piece was distributed to prospective and existing clients as well as to the media. It was also picked up by a publisher to be distributed throughout Europe.

LEFTT: Chapter five, "On the Edge of Legibility," deals with experimental typography that plays with what is legible and what is not.

redpath

CLIENT:
Redpath is a graphic design
company that employs both
designers and writers.

FIRM:
Redpath

CREATIVE DIRECTOR:
Iain Lauder

DESIGNERS:
Jason Little and Iain Lauder

PHOTOGRAPHER:
The Picture House

COPYWRITERS:
Richard Irvine and Gerry O'Regan

ABOVE: The front cover hosts the
firm's new identity icon, a graphic
interpretation of words and pictures.
Each page, including the cover, is
French-folded with die-cutting and
blind embossing as accents to
create variety and interest. The
entire piece is bound using two
staples. The back cover overlaps
and folds under onto the front,
covering the staples.

Words and Pictures

Redpath has something unique to offer clients that their
competition does not. Unlike most design firms in the
United Kingdom, Redpath employs both designers and
writers to solve their clients' communication problems.
"What sets us apart is the way we approach our projects,"
says creative director Iain Lauder. "Because everything we
do is in words and pictures, we are different, and that is
something we wanted to communicate in the brochure."
Right from the cover design, the idea of combining words
with pictures is conveyed. The fluorescent orange, a
corporate color, draws your eye in, and the new identity
icon intrigues you to read on. "We wanted this brochure to
really jump out at you and not get lost on someone's desk,"
shares Lauder. "When you look inside, it is quite simple and
clearly explains the company and how we view ourselves."
The brochure begins by detailing the firm's unique
approach to communications and finishes by presenting
various client projects, each covering a variety of industries.
To capture attention and create interest, various production
techniques were brought in. "When doing your own
brochure, you always try to push the boundaries," offers
Lauder. "We experimented with different printing tech-
niques a bit—doing things that we do not always get to
do. The techniques allowed us to explain our whole
process in an entertaining way."

The biggest hurdle for the design firm was just getting
the job done. "We spent quite a bit of time internally—
working on the project until we felt that we had something
that worked," recalls Lauder. "Because we were pushing
the writing side, it was important that the words were
absolutely right." The entire piece took about six months
to complete, taking on many shapes and directions
along the way.

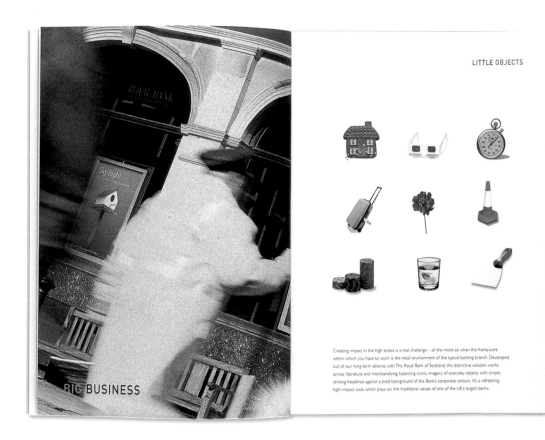

LITTLE OBJECTS

Creating impact in the high street is a real challenge – all the more so when the framework within which you have to work is the retail environment of the typical banking branch. Developed out of our long-term alliance with The Royal Bank of Scotland, this distinctive solution works across literature and merchandising, balancing iconic imagery of everyday objects with simple, striking headlines against a bold background of the Bank's corporate colours. It's a refreshing, high-impact look, which plays on the traditional values of one of the UK's largest banks.

BIG BUSINESS

LEFT: **Several client projects, covering a variety of industries, helped to support the design firm's unique approach to solving communications problems.**

What Works

The rich balance of words and pictures helped to communicate Redpath as unique among its competitors. The brilliant colors, interesting use of production techniques, and imagery made the brochure eye-catching, while the clarity of the copy made it memorable. "It has been very successful," says Lauder. "We have recently had a number of leads with several major clients responding to the piece. They like that we offer them more than other design companies."

michael osborne design, one heart press, anne telford, and cathie bleck

CLIENT:
Michael Osborne, a graphic designer and owner of One Heart Press, **Anne Telford**, a writer, and **Cathie Bleck**, an illustrator, all worked collaboratively on a self-promotion piece.

FIRM:
Michael Osborne Design, One Heart Press, Anne Telford, and Cathie Bleck

ART DIRECTOR/DESIGNER:
Michael Osborne

ILLUSTRATOR:
Cathie Bleck

COPYWRITER:
Anne Telford

ABOVE: The accordion-folded book was printed on Somerset White. The self-wrapping cover, with its hand-applied label, was produced using BFK Reeves paper.

From the Heart

It all started with the AIGA "Y" conference in San Diego entitled *Connectivity*. "At the conference, many people focused their presentations on collaboration and connecting with other people," recalls illustrator Cathie Bleck. "It was a real energizing experience." After leaving the conference, all three collaborators were quite inspired and decided to get together for lunch to discuss a possible joint endeavor. "I thought we could do something that I would design and print, Cathie would illustrate, and Anne would write—something that displayed all of our individual talents in one piece," says designer Michael Osborne. Bleck adds, "At lunch, we talked a lot about what the piece would be about. As we were looking at the dessert menu, we noticed that one of the desserts was called Three More Bites. It was a revelation! Our book would include three poems, three pieces of art, and we would call it *Three More Bites*."

The project started with writer Anne Telford. "We asked her to lead the way," notes Osborne. "She sent over several short poems, and we narrowed it down to three." Both the illustrator and writer worked together to select just the right ones for the small, yet intimate book. "I have a large body of poetry to draw from and was very open to having Cathie choose what she related to," says Telford. "In her illustrations, Cathie really got to the heart and soul of what I was writing about." Portraying three central female figures, the illustrations add richness to each page. "It was in the spirit of working with Cathie and the inspiration we drew from the women in our lives," shares Telford.

The type, subtly displayed in warm gray, is both eloquent and graceful. "It is real easy on your eye, and the writing and illustration still remain the heroes," adds Osborne. Once complete, the entire edition was sent to the illustrator and writer to hand-sign.

night[time]

Open to the sky,

a field of lights at my shoulder,

I stare at the night,

and will it to be longer.

What Works

Because of the quality and attention to detail, the collaborative promotional piece drew attention from everyone who received it. All of the special touches and care that were put into the piece made it something worth holding on to. "I have gotten so many e-mails, and a lot of them were similar in tone," remarks Osborne. "The responses, much like the piece itself, were warm and heartfelt." The handcrafted piece really celebrates illustration, design, and writing and inspires others to do the same.

ABOVE: The book was distributed in a box that was stuffed and wrapped with a specially designed band. Only 300 were produced.

One Step Beyond

The Graphic Use of Typography

In design, type can be more than mere words on a page. Used properly, it can be an effective tool to enhance a communications message. When designer Matt Ralph envisioned an educational brochure for Antioch College, he wanted to use type as a way to reinforce the feeling of experiencing the college and its students firsthand. "The college is an interesting place. They have different kinds of programs and courses that support the students' interest and commitment to social and environmental issues," says Ralph. "Rather than design a book that is organized by departments, I decided to design it as a random walk-through. I wanted the type to reinforce that by changing quite a bit as you go through the book. In some places the type would be simple and quiet and a little more reflective, while in other places it would become a more playful and exuberant, and in others it would get big, bold, and loud." Ralph chose to use type as a way to bring out the variety and diversity of the small town college. As you look at each spread, you are introduced to a new aspect of the school and its unique student body.

Type can also be an expressive, almost pictorial, element used to give visual impact to a page. In a promotional brochure for illustrator Rick Sealock, designer Ken Bessie used type in a highly visual way. "I thought a lot about how I wanted the reader to perceive the type," recalls Bessie. "I went with an asymmetrical type layout because Rick's illustrations are so colorful and aggressive." Bessie's painterly use of type brought variety and spontaneity to each spread. "I wanted to do something a little bit different on every page. I'd put a lowercase letter in a full cap word, change the color for one letter, jump the baseline, and use different point sizes and leading in the same text block," details Bessie. "When words repeated or when punctuation was used, I really wanted the reader to get a sense of the emphasis on these words. I wanted the piece to be typographically fun to read." Through his inventive and playful use of type, Bessie was able to tell a visual story while also highlighting the illustrator's whimsical work.

By far, the most important aspect of type is that it be legible to ensure that the communications is clearly disseminated. "You have to think about your audience," concludes Ralph. "Once the information is readable and understandable, you can go off and be more expressive and playful. I like work that blends the two."

CLIENT:
Rick Sealock is a whimsical
illustrator working in Alberta,
Canada.

FIRM:
Blackletter Design

ART DIRECTOR:
Rick Sealock

DESIGNER:
Ken Bessie

ILLUSTRATOR/COPYWRITER:
Rick Sealock

ABOVE: Taking a children's story-
book approach, the 14-page
promotional piece was created to
attract the attention of a variety
of clients—editorial, publishing,
and advertising. The asymmetrical
layout and whimsical use of
type reflects the story and the
imagery—colorful, energetic,
and fun.

ABOVE: Two typefaces,
Clarendon and ITC New
Baskerville, are used
throughout the illustrative
promotional book.

CLIENT:
Antioch College is a liberal arts college in Ohio where individuality and independence are nurtured.

FIRM:
Plainspoke

ART DIRECTOR:
Matt Ralph

DESIGNERS:
Matt Ralph and Stephanie Brazeal

PHOTOGRAPHERS:
Brian Wilder and Dennie Eagleson

COPYWRITER:
David Treadwell

RIGHT: The educational brochure is designed to convey the feeling of walking through the Antioch College campus—experiencing the culture, people, and unique programs. The brochure was mailed to prospective students in a custom-designed envelope.

ABOVE AND CENTER RIGHT: The profile pages help to reinforce the cultural diversity and interests of the student body. By varying the posture, height, and weight and repositioning the kerning, leading, and column structure, Ralph was able to portray Antioch College with clarity and impact. The typefaces vary from Garage Gothic to Trade Gothic with Mrs. Eaves as an accent.

BELOW RIGHT: Within the brochure, actual postcards are reproduced to highlight the study abroad program in a fun and personal way.

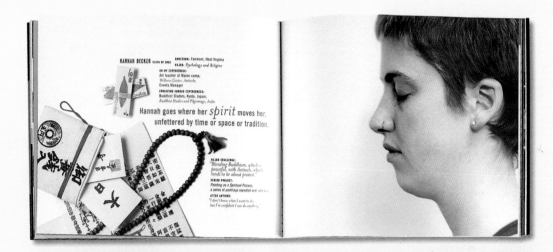

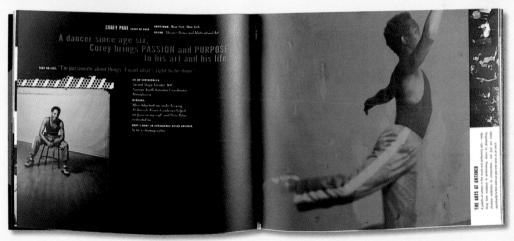

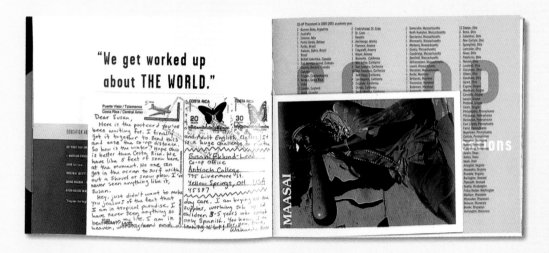

aiga national design conference

CLIENT:
The American Institute of Graphic Arts' National Design Conference is held to inspire and promote thought and discussion within the industry.

FIRM:
Cahan & Associates

CREATIVE DIRECTOR:
Bill Cahan

DESIGNERS:
Bob Dinetz, Sharrie Brooks, Kevin Roberson, Michael Braley, and Gary Williams

PHOTOGRAPHERS:
Bob Dinetz and Kevin Roberson

COPYWRITERS:
AIGA, Kevin Roberson, Bob Dinetz, and Gary Williams

ABOVE: The cover image sets the stage for the provocative program guide. Throughout the book, questions are posed to evoke thought and discussion.

Changing the World?

The American Institute of Graphic Arts' (AIGA) National Design Conference needed a program guide to distribute at its September 2001 event. The tendency to do a piece that was a derivative of previous years' guides was tempting. "A lot of the program guides in the past have been mostly visual gymnastics in an effort to speak to the audience," comments creative director Bill Cahan. Designer Bob Dinetz agrees, "We did not want to do that. The challenge was in restraint."

The theme of the conference, *Voice: Can Design Change the World?*, was the starting point for the creative team at Cahan & Associates. At first inspection, the group of designers responded negatively to the question at hand. But after closer inspection, they realized the question was rhetorical, and from there they developed a direction. Changing their focus from a global interpretation to a more local one, the design team explored the power and simplicity in the voice of an individual. "We found the idea *Can Design Change the World?* a little lofty, and we wanted to focus on smaller causes—things on a local

level that could cause change, persuade, inform, or influence people," says Dinetz. "We could have just done a program guide, but we chose to do more than that."

To illustrate the idea, the design team went into their local community and photographed a variety of urban surfaces that displayed printed and handwritten social, political, and religious statements. "The most powerful work often comes not from marketing expertise or technical virtuosity, but from desperation, passion, and honesty," acknowledges the design team. Once the images were shot, the group of designers arranged and cropped them to create just the right sequencing and pacing. The resulting piece was highly thought-provoking and functional at the same time. As eloquently stated in the program guide, "Our hope is that we all can take a cue from these voices and find our own."

What Works

Because of the events of September 11, the conference was canceled. The engaging piece was, however, distributed to all registered participants by mail, and the message of making change on a local level was delivered and well received.

LEFT: A series of images, shot in the streets of San Francisco, are featured throughout the program guide. They focus on expressing one's voice and inspiring change.

LEFT: The functional pages contain all of the lecture content and speakers over the three-day conference.

casa da música

CLIENT:
Casa da Música is an
opera house.

FIRM:
R2 Design

ART DIRECTORS/DESIGNERS:
Lizá Defossez Ramalho,
Artur Rebelo

PHOTOGRAPHERS:
Pedro Magalhães and
Henrique Delgado

COPYWRITERS:
António Jorge Pacheco,
Luís Madureira, Nuno Carrinhas,
Cristina Fernandes, Ricardo Pais,
Brad Cohen, and Adrian Mourby

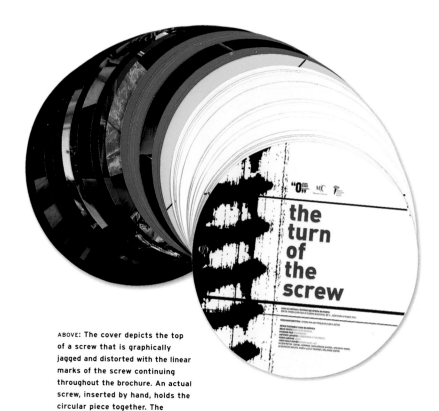

ABOVE: The cover depicts the top
of a screw that is graphically
jagged and distorted with the linear
marks of the screw continuing
throughout the brochure. An actual
screw, inserted by hand, holds the
circular piece together. The
uniquely round brochure can be
opened either by fanning or
flipping. It is up to the viewer
to decide.

Good vs. Evil

Casa da Música was looking for a single brochure to
depict two different opera performances by the group
Estúdio de Ópera do Porto. *The Turn of the Screw* and
L'Amore Industrioso were to exist in the same brochure
but function independently. "Opera brochures, at least
in Portugal, are very traditional and a bit classical,"
acknowledges art director Lizá Defossez Ramalho. "With
this piece, the client wanted something different,
something that would reach people, and he gave us the
freedom to add our own interpretation." To solve the
functional aspect of the brochure, the design team chose
to run the operas back-to-back. *The Turn of the Screw* is
on one side and *L'Amore Industrioso* is on the reverse.

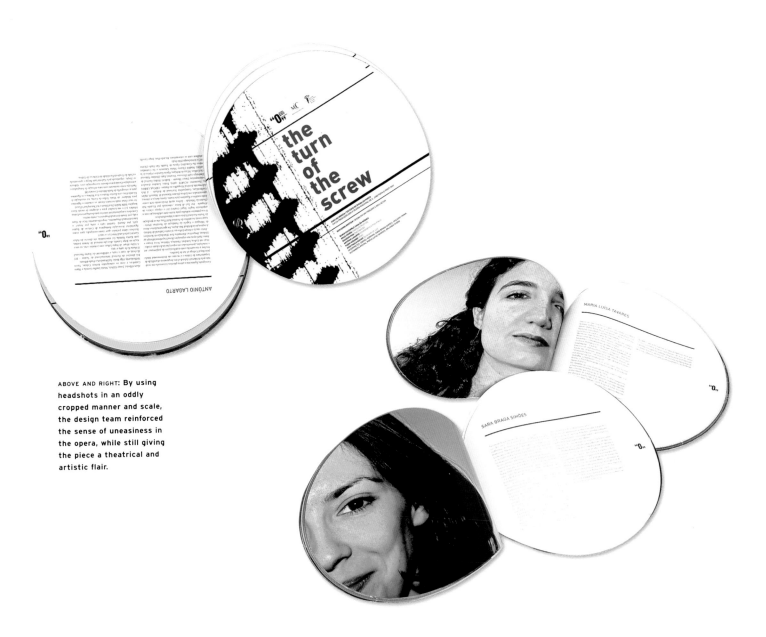

ABOVE AND RIGHT: By using
headshots in an oddly
cropped manner and scale,
the design team reinforced
the sense of uneasiness in
the opera, while still giving
the piece a theatrical and
artistic flair.

Because the text and graphics already existed for *L'Amore Industrioso*, the design team focused their efforts on *Turn of the Screw*, a gothic horror story about the strange things that happen to a governess and the two orphan children in her care. "There are ghosts, and they come to play with the children and, in a sense, abuse them," recalls Ramalho. "There are two opposing feelings. There are these awful things that happen in the story, but with that, there are a few moments of joy. When you turn the pages you get different feelings." As you move throughout the brochure, solemnly colored pages gradually begin to brighten. The juxtaposition of color helps to balance the moments of joy with those of sorrow. "It was a challenge to create a brochure for an opera that we couldn't see," comments Ramalho. "Instead, we read the text, met with the director and music coordinator, and went to the theater to see drawings of the clothes and the backgrounds." With no performance photos to work with, the design team chose to focus on the performers. "We wanted the portraits to be a bit suffocated in the confines of the brochure," notes Ramalho. "To establish intimacy, we wanted to get a close proximity in scale between the people who are reading the brochure and the portraits." The aggressive use of portrait photography helped to portray the pressure that the children were feeling throughout the opera.

What Works

Distributed at the end of each opera, this nontraditional brochure captivated its audience much like the opera itself. "We attended the opera and saw the people getting the brochures, and they were very excited because it was so different—round and colorful," offers Ramalho. "The client also saw the people wanting to grab the brochure. All of the actors and the people who worked on the opera were also very pleased."

air team

CLIENT:
Air Team organizes action shows throughout Europe, such as the Motocross Freestyle World Cup.

FIRM:
Starshot

ART DIRECTOR:
Lars Harmsen

DESIGNER:
Tina Weisser

PHOTOGRAPHER:
Kai Stuht

RIGHT: The three-panel letter-fold brochure is accented with several fonts—Platelet, OCR, and Grotesque. It also includes a CD-ROM, which contains various full-color images of the event—the unique stunts and the stars that perform them.

Dramatic Action

Always seeking great locations to hold their sporting events, Air Team wanted a stunning promotional brochure to give city decision makers a sense of the excitement that the motocross freestyle event could bring to their community. "They wanted to have a very mysterious and very graphic piece that captured the idea of the show. They did not want us to use clean, straightforward images," recalls art director Lars Harmsen. "The competition itself was less important than everything else that surrounds the show." Much like a theatrical performance, lighting, drama, and anticipation all work together to engage the audience. "It's very magical, like the circus," Harmsen adds. "Indoors most of the time, the shows work with music, fog, fireworks, and big lighting systems to capture the effect."

Because this was new territory for the design team, a lot of preliminary research was conducted through reading motocross literature and talking with event competitors. "We needed to find out which stunts were new and innovative in the motocross business," comments Harmsen. "We didn't want to capture something that someone in the motocross scene would consider not very challenging." Because the photography had to be captured at a live event, the design team had only one opportunity to get it right. "Action photography is very difficult. You can't look at a Polaroid and discuss every little tiny piece," remarks Harmsen. "When it's live, you can't control the lights, and it is very difficult to get predictable results." By using the process colors in a high-contrast and monochromatic fashion, the brochure was able to get across the overall concept of drama, action, and sense of discovery. With the addition of silver, fluorescent green, and spot varnish, the piece became vibrant, exciting, and theatrical.

out of America took the
... "Night of the
the SachsenARENA in
...rmany. The trophy went to
...Jones on Friday night in front of
...000 spectators. One day later
...spectators cheered Tommy
...owers to his victory.

...hey stated that the event was a
...not only meaning the sold out
...happy that everything went so
...aid the head of organization at
...e Night of the Jumps. "After
...was the premier event
...estyle motocross in
...e people were fantastic and the
...with the city of Riesa was
..., giving out compliments and
...this wasn't the last time that
...World Cup landed in Riesa. The

best riders came out of the US on both nights. Mike
Jones won on Friday evening in front of a crowd of
"only" 3.000 spectators that due to the bad weather
and icy roads managed to make it to the venue. 24
Hours later however Tommy Clowers took
the stage in front of a sold out
audience. Clowers: "I sprained my wrist on Friday
night on a hard landing, but that isn't a problem
today (Saturday)". He showed all the tricks that he
planned on doing. The American convinced the 5-man
Jury through the amount of jumps, his variation,
difficulty, and perfection. The Germans played a
smaller roll. Sebastian Wolter only made it into the
finals Friday evening because Stefano Minguzzi (ITA)
hurt himself and had to break off his run so that
Sebastian moved up a position. On the second night
the Italian was on the track again with a broken right
foot and made it into the finals. "That shows
what these guys are made of" said
Marko Manthey. Still the German Sebastian Wolter
was pleased: "It was more fun today (Saturday) than
yesterday because the track was improved overnight
and the spectators really got into it. It's not so bad
then if I didn't make it into the finals.

...00

...Amerikaner haben den
...des IFMXF-Weltpokals der
...otocrosser in der
...SachsenARENA ihren Stempel
...Die erste "Nacht der
...ntschied von Freitag auf Sonnabend
...vor mehr als 3.000 Zuschauern für
...Tag später sahen über 5.000 Besu-
...von Tommy Clowers.

...hey sprach von einem vollen Erfolg
...damit nicht nur die ausverkaufte
...ENA in Riesa. "Ich bin froh, dass
...bungslos abließ", sagte der Chef-
...nach dem Ende der Night of the
...lließlich sie es die Premiere zum
...er Freestyle-Motocrosser gewesen.
...ublikum war fantas-
...d die Zusammenarbeit mit der Stadt
...", verteilte er Komplimente und
...n Wiedersehen im nächsten Jahr.

Aus den USA kamen auch die besten Fahrer an beiden
Tagen. Am Freitagabend gewann Mike Jones. Seinen Sieg
sahen wegen der schlechten Straßenverhältnisse und
Witterungsbedingungen "nur" gut 3.000 Gäste. 24
Stunden danach machte ihm Tommy Clowers vor
ausverkauftem Haus einen Strich durch die Rechnung.
"Ich habe mir gestern zwar das Handgelenk bei einer
harten Landung verstaucht, aber das ist heute (Samstag)
kein Problem gewesen", sagte der vom Publikum total
begeisterte 28-Jährige. Er habe alle Tricks ge-
zeigt, die er sich vorgenommen hatte. Die US-Amerikaner
überzeugte die fünfköpfige Jury nicht nur durch Anzahl
und Vielfalt seiner Sprünge, sondern auch mit der Aus-
führung und Schwierigkeit. Die Deutschen spielten nur eine
Nebenrolle. Sebastian Wolter schaffte den Sprung ins erste
Finale mehr durch Glück als Können. Der nach dem
Hoffnungslauf vor ihm platzierte Stefano Minguzzi schied
verletzt aus, so dass der Kölner nachrückte. In der zweiten
Nacht trat der Italiener trotz eines gebrochenen rechten
Fußes an und schaffte den Sprung in die Entscheidung.
"Das zeigt, aus welchem Holz die Fahrer
geschnitzt sind", meinte Marko Manthey.
Der Deutsche war dennoch zufrieden: "Es
hat heute (Saestag) mehr Spaß gemacht
als gestern, weil die Strecke besser war und die
Zuschauer super mitgegangen sind" meinte Sebastian
Wolter. Da ist es nicht so schlimm, dass es bei mir nicht

NIGHT O
motocross
JUMP
25
01

What Works

The highly dramatic promotional brochure captured the
thrill and excitement of the motocross event by utilizing
a high-contrast monochromatic color scheme that was
accented with silver, fluorescent green, and spot
varnish. Used to book premier locations for the
motocross event and to attract the attention of top
competitors, this engaging event brochure brought an
increase of 20% more bookings for Air Team.

ABOVE: To get an artistic and
mysterious effect, Polaroid
PolaPan film, which can be
developed on location, was used.
"When you blow it up, you get
this wonderful grain that we
emphasized in Adobe Photoshop,"
shares Harmsen. "I find the look
quite interesting, because you
are not sure what is happening."

the national illustration conference

CLIENT:
The National Illustration Conference is a nonprofit organization whose purpose is to provide a platform for illustrators to address issues facing the industry.

FIRM:
Murphy Design Inc.

ART DIRECTOR/DESIGNER:
Mark Murphy

ILLUSTRATORS:
Joel Nakamura, Amy Guipp, Gary Taxali, Cathie Bleck, Vivienne Flesher, Gerard DuBois, Christian Northeast, and Mick Wiggins

COPYWRITER:
Anne Telford

ABOVE AND TOP RIGHT: The motivational brochure features the work of various illustrators and styles to generate a broad range of interest in the conference. The focus is on empowerment and reinvention.

Power in Unity

At the first National Illustration Conference, many illustrators emerged from their studios to unite. It was a crisis meeting to address industry-related concerns and discuss potential solutions. This grassroots effort began a movement of unity and empowerment that has since gained momentum. "The whole idea behind the conference was to bring illustrators together to talk about serious issues facing the industry—fees, stock, and copyright issues," reflects art director Mark Murphy. "We were trying to generate interest and get across the concept that the future starts with you."

This illustrated six-paneled self-mailer, designed to maximize the press sheet and to minimize postage costs, engages the reader with a variety of visually rich content. "My idea was to take different styles of illustration, people that were prominent in the business, and blend them together in one piece. I chose Cathie Bleck, whose work is feminine and sensitive, and juxtaposed her with Gary Taxali, who is a little more irreverent. I had to find a balance in styles because illustration is such a subjective art form," remarks Murphy. "It also helped to attract a variety of illustrators to the conference." The interesting texture that accents the brochure throughout was created with a Xerox machine. "I scanned in the texture as a black-and-white TIFF file and kept the resolution high so that it could be made larger or smaller," details Murphy. "I then added color at will and layered it in Quark." The designer has, over the years, built an extensive collection of textures that he utilizes in various assignments.

As the outside excites, the inside spread outlines the two-day conference agenda—motivating people to register. The mailer is part of a series. Several postcards were also created to spread the word and generate interest for the conference. All of the artwork, design, paper, and printing were donated.

What Works

"Because the brochure had a community feel and did not center on any one illustrator or style, but on many making up one industry, it excited a lot of people to connect," says Murphy. "There was room for 500 people at the conference, and they sold out."

ABOVE: The inside six-panel spread houses the schedule of events and registration form.

the seattle supersonics

CLIENT:
The Seattle Supersonics are a professional basketball team.

FIRM:
Hornall Anderson Design Works

CREATIVE DIRECTOR:
Jack Anderson

ART DIRECTORS/DESIGNERS:
Mark Popich and
Andrew Wicklund

PHOTOGRAPHERS:
Alex Hayden, Jeff Reinking/NBA Photos, and various stock

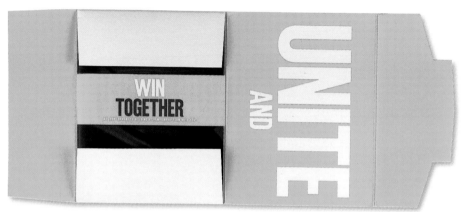

ABOVE: **The pocket folder, with its bold messaging, entices the reader to open it. Inside sits the renewal brochure wrapped by a bellyband.**

Classic Basketball

The Sonics had come under new ownership that was interested in rebranding the team. The new owners' vision was to bring the fans back into the game. By showing inspirational imagery and sincere text, the brochure identifies and connects with the fan base. The bold use of type and image makes the piece easy to read and the communications clear. "We knew right away that this piece had to be open and honest. It couldn't be full of tricks and gimmicks," details creative director Jack Anderson. "It had to be genuine in its touch and message where each page talks about renewing passion, responsibility, commitment, and respect." As part of the new brand, the team's logo, uniforms, tickets, and overall color scheme were all changed. "We basically went back to the colors that they used to have— green and yellow. We also brought back the arch,"

RENEW

SEATTLE SUPERSONICS 2001–02 SEASON TICKETS

RENEW
RESPECT

for tradition, coaches, players and yourself

recalls Anderson. "Years ago, there was honesty about the team. It was a rich heritage that we wanted to bring back."

Throughout the renewal brochure, four-color photos are interesting intermixed with an array of monochromatic imagery—giving it that classic look. The simple, genuine, and heartfelt brochure was sent to season-ticket holders to renew their subscription. "The Sonics had come off a bad season. There was a new ownership and talk of significant trades," recalls Anderson. "At the time, people were wondering if they could justify buying season tickets again." Because a huge part of the team's income stream comes from season-ticket sales, this communications devise was very important not only to the new management but to the future of the team.

What Works

The integrity and honesty of the piece helped to inspire fans to recommit to their beloved team for another season. "The fan base had some drift and continued fall off in the past," claims Anderson. "This piece helped to stop the flow on that. The whole program has become a model for other teams to follow."

ABOVE: **Beginning with a renewal theme, the cover is bold and simple with the background acting as a textural support. Each spread communicates a different aspect of the overall message. The brochure is printed in four-color process plus two PMS colors for the team's new colors—green and yellow.**

the fine arts museums of san francisco

CLIENT:
The Fine Arts Museums of San Francisco, comprised of the M.H. de Young Memorial Museum and the California Palace of the Legion of Honor, is the city's largest public arts institution.

FIRM:
Cahan & Associates

CREATIVE DIRECTOR:
Bill Cahan

DESIGNER:
Michael Braley

PHOTOGRAPHER:
Jock McDonald

COPYWRITER:
Peterson Skolnick & Dodge

We've listened.

ABOVE: **The saddle-stitched brochure is one in a series of mailings. It is sent folded in a translucent envelope to members and supporters of the museum.**

Publicly Speaking

The M.H. de Young Memorial Museum, set in Golden Gate Park, was in the midst of designing a new architectural structure to house and display its diverse collection of art. The oldest museum in San Francisco was to be completely demolished and replaced with a more contemporary structure and needed money to fund the endeavor. The new and quite controversial design, however, was not well received by the community at large, making it even more difficult to raise the necessary funds. "I attended several hearings and talked to people, trying to get a sense of what their issues were. A lot of people were unhappy with the architecture of the new building," shares designer Michael Braley. "They didn't think that it fit in with the existing park space." To counteract the negative publicity, the design team at Cahan & Associates was brought in to develop a series of direct mail pieces that would not only calm public adversity but would also raise awareness and money for the new structure. This tabloid-size brochure is the second in a series of four mailings. "We wanted to show that they were paying attention to the public's concerns," notes creative director Bill Cahan.

Throughout the brochure, large-scale portraits of the individuals intimately involved in the new museum are featured along with an image symbolizing their contribution to the project. The brochure goes back and forth between image and copy to convey that the newly proposed museum is not just the creation of a select group of individuals, but it is a museum for everyone to share. "It's not about architecture. It's about a collection and a gathering place—a destination for people to mingle and experience culture from all over the world," adds Cahan.

my sketch

your museum

LEFT: **Each spread features large-scale portraits of the landscape architect, builder, curator, and architect who are intimately involved in the redesign. Opposite the portraits is an image and quote, which detail each person's contribution to the project and what it means to the public.**

my garden

your retreat

What Works

By taking a personal approach, the eye-catching brochure was able to communicate that the museum is a gathering place for everyone to enjoy, not just the artistic vision of a select few. Along with three other mailers, the brochure has raised awareness and the necessary funding for the new museum to shine in San Francisco's Golden Gate Park. "We have gotten great responses from the piece, and it really has benefited the museum," adds Cahan. The piece's ability to be sensitive to public concern has paid off.

the council of europe

CLIENT:
The Council of Europe is an
intergovernmental organization
that aims to protect human rights,
promote awareness of and
encourage cultural diversity, seek
solutions to problems facing the
European society, and help
consolidate democratic stability.

FIRM:
Summa

ART DIRECTOR:
Wladmir Marnich

DESIGNERS:
Eduardo Cortada and
Griselda Marti

PHOTOGRAPHERS:
Josep Maria Bas, Eduardo Cortada,
and Stone Photo Library

COPYWRITERS:
Norbert Paul Engel and
Renee Gautron

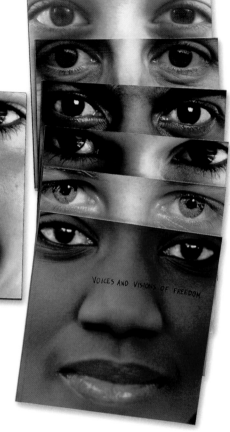

ABOVE: A series of six books, each
entitled *The Voices and Visions of
Freedom,* is written in various
languages—English, French,
Spanish, German, Italian, and
Russian. Each laminated book
is color-coded on the spine to
match the color of the text inside.
Collectively they fit together in a
specially designed, laminated box.

Multicultural Approach

The Council of Europe needed a piece to distribute at
the celebration of the fiftieth anniversary of the Human
Rights Convention. In 1950, an agreement was reached,
culminating the signing of the convention for the protection
of human rights and fundamental freedoms—a major
milestone in European history. For the first time, citizens
could claim rights under international law against states,
including their own.

To better understand what the Human Rights Convention
was all about, the art director went to Strasbourg, France,
to visit the Council of Europe. "They explained to me how
things worked and how human rights issues are treated
within the council," notes art director Wladmir Marnich.
"I also interviewed the author who wrote the book, a
specialist in human rights issues." Upon his return, a
design direction was established. Using mostly conceptual
imagery, the initial design attempted to communicate the
various articles and rights put out by the council. "In the

Article 8. The right to respect for private and family life. *[text too small to read]*

PURSUIT OF HAPPINESS
THROUGH PRIVACY

beginning, we had presented a more abstract design, and it was approved," recalls Marnich. "When we went to work on the cover of the book, I saw an image of a face. I thought it would be great, but it had nothing to do with the inside. So, at the very last minute, I decided to change the whole book." Taking on a more multicultural approach, the design team reorganized the book and the design to incorporate a series of faces—diverse in ethnic background, gender, and age. Because of restrictions in budget and time, the design team solicited friends, family, and acquaintances to be photographed for the book. "We wanted to use everyday faces, not actors or models. I didn't want any decoration or distractions in the book," says Marnich. "We also wanted each person to send a message to the parliamentarians in his or her own handwriting. It was a small detail, but truthful to the idea." Tightly cropped portraits are accented with handwritten messages that act as headers to each section.

What Works

Because the piece took on a multicultural and multilingual approach, it appealed to a variety of people equally. The sensitivity to the issues and the personal touches that exist throughout made it heartfelt and enriching. "At the celebration, each person would take the brochure with the language they knew. The box set was a special gift for presidents, vice presidents, and people in high positions within the Council of Europe," shares Marnich. "The client was pleased, and everyone was happy about the end result."

ABOVE: Each section is dedicated to one particular issue and features a portrait, a personal message, and some explanatory body copy. To give movement and pacing throughout the piece, each portrait is shot at a slightly different angle.

the sahara center

CLIENT:
The Sahara Center is a family shopping and entertainment center located in Sharjah in the United Arab Emirates.

FIRM:
Thumbnail Creative Group

CREATIVE DIRECTOR:
Rik Klingle

DESIGNERS:
Valerie Turnbull and Lindsay Rankin

COPYWRITER:
Rik Klingle

ABOVE: The embossed cover is printed in a gradation of midnight blue and accented by the brilliance of the logo. The overall pocket folder is designed with interesting angles and curvilinear die-cuts–alluding to the dramatic architecture of the Sahara Center. In the arched pocket fits several inserts as well as a CD-ROM and business card.

Arabian Flair

"Our concept for this leasing folder, with its elegant proprietary shape and rich, stunning color, was to position the center as a prestigious and multifaceted jewel in the crown of Al Nahda," comments creative director Rik Klingle. "The Sahara Center, with its unique approach to shopping, represents the new direction in retail and leisure malls of the future."

Inspired by the romance of the Sahara, the gradated midnight blue cover, symbolic of the cool of night, opens up to a rich orange inspired by the warmth of the desert sun. "We felt that it was appropriate to allude to both night and day, because the Sahara Center can offer retail and entertainment experiences virtually 24 hours a day," adds Klingle. The overall dramatic shape and curvilinear die-cuts play nicely off the center's unique architectural design. The insert

pages, designed to be easily accessible and update-able, fit nicely inside an arched pocket, which also houses a CD-ROM and business card. "One of the reasons why the pages were individual and not bound in was because things had not been totally solidified at the time," explains Klingle. "We went with a pocket folder because the information was changing as we were designing it. It is easier and more cost-effective to revise and reprint an insert sheet, at a later date, than it is to redo the entire folder." The complete package was created to attract North American retailers to the new and exciting family shopping and entertainment center.

What Works

With its interesting angles, curvilinear die-cuts, and vibrant color scheme, the dramatic and energetic leasing brochure excited many North American retailers—attracting enough of them to completely fill the vast space. Because of the success of the brochure, the design team was also asked to create a website and provide the creative for the center's grand-opening campaign.

golden books

CLIENT:
Golden Books is a publisher of children's books and entertainment.

FIRM:
SJI Associates Inc.

ART DIRECTOR:
Jill Vinitsky

DESIGNER:
Alex Rekasi

ILLUSTRATIONS:
Nickelodeon

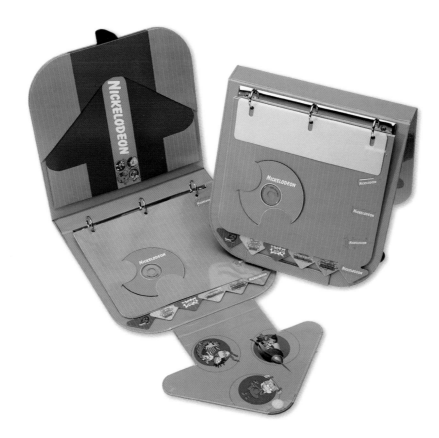

ABOVE: The fun and inviting promotional kit folds back on itself to become a self-standing presentation binder.

Presenting Entertainment

Golden Books needed an interesting and captivating way to announce to prospective buyers their acquisition of the rights to use Nickelodeon characters in their books. "They were really excited about it, and they wanted their sales staff to be really excited about it," recalls SJI Associates president, Suzy Jurist. "So, they hired us to come up with a sales kit that would give Nickelodeon its own presence. We really tried to talk to the brand of Nickelodeon while letting the inside pages speak to the individual properties of Nickelodeon."

Because the promotional piece had to be functional as well as visually appealing, the design team came up with a binder design that wraps backwards around itself and becomes a self-standing sales tool. The custom binder houses several divider pages, information about the books, and a CD-ROM. "It needed to be in a presentation format so that the salespeople didn't have to hold it," adds Jurist. "It

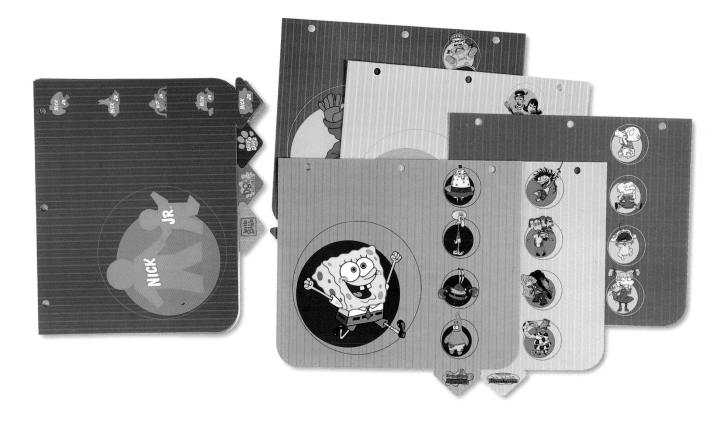

also made it easier to flip through the different sections."
To come up with just the right structure, the project designer
did extensive research—analyzing the design of other
sales kits and their approach to children's graphics. "The
main thing was to communicate a very friendly and open
feeling, being careful not to be too strict or stuffy," says
designer Alex Rekasi. "Both the fonts and the graphics
needed to be light-hearted and communicate easily." Using
arrows and stripes, the playful and friendly promotional kit
draws the reader's attention into the content. "It's an
intriguing piece that makes you want to open it," notes
Jurist. "Once you are in it, it is very well organized." All of
the logos, artwork, and color schemes were provided by
Nickelodeon. The binder, wrapped with a 70-lb. litho sheet,
was printed in four-color process with a gloss film lamination
on top. The interior divider pages were also printed in
process with a gloss film lamination on both sides. Only
100 were produced.

What Works

The childlike shape and vibrant color scheme helped to
attract attention to the Nickelodeon brand. The eye-catching
promotional package, functioning not only as a brochure
but also as a presentation binder, made it easy for the
sales staff to introduce and promote the new line of books
to prospective customers. "It was received incredibly well
not only by the sales staff but also by the people they were
selling to," offers Jurist.

ABOVE: **The interior dividers help
to organize the sales information
on various books based on
Nickelodeon's line of characters.**

One Step Beyond

Using Grids and Templates

Grids and templates provide a way to organize information and to create balance, unity, and visual rhythm throughout any communications piece. Whether the usage is subtle or quite apparent, an underlying grid can be useful in keeping the reader focused and the communications clear and consistent. "Throughout any piece there has to be something that reoccurs for the reader. Things can vary as long as they are in a common place where they can be found," shares creative director David Cannon. "I think it is important to have a grid system in place to anchor hierarchies of information."

Using a grid system does not mean sacrificing creativity or expression. Like music, variety must occur within the overall structure to maintain interest. By slightly varying the elements within a grid, the page or spread will come alive, creating movement and pacing from one page to the next. Establishing relationships amongst the elements within a layout is also important. By flushing elements to the same grid line helps to establish order. Repeating or echoing similar shapes or textures creates an overall rhythm in a piece. There is also a connection between the outside shape and the interior space of a layout. When choosing an exterior format, keep in mind how it will effect what is going on inside. Varying either one will greatly change the flow, continuity, and organization of a piece. It's best to experiment to find just the right combination to most effectively communicate the client's overall message.

With the convenience and speed of the computer, grids and templates are easier than ever to set up and use. "With the advent of computers, the design grid has been brought to the masses. Now, setting up a grid is as simple as a few clicks of a mouse," offers art director Shawn Murenbeeld. "Knowing what to do once the grid is established is another matter entirely." With this technological advance, a certain level of artistic sensitivity has been compromised, and many designers have lost touch with the craft of constructing a page. The best way to counteract such a loss is to examine the work of the old masters, the great designers of the past. They used and experimented with all kinds of grid systems to produce their work. "Some examples of the earliest and best uses of grids were created by designers in movements like Constructivism, Bauhaus, De Stijl, and later in the Swiss or International Style," adds Murenbeeld. "When you look at the works of Laszlo Moholy-Nagy, El Lissitzky, Jan Tschichold, and Josef Muller-Brockmann, to name a few, you'll see that as well as being practitioners of the grid, they were also pioneers of modern typography." Going back to the basics not only can enrich your understanding of what is possible but can also act as a springboard for your own creative exploration.

CLIENT:
DWL Incorporated's enterprise customer management applications consolidate fragmented customer relationship management (CRM), back-office, and e-business systems into unified industry solutions.

FIRM:
DWL Incorporated
(in-house creative services)

ART DIRECTOR/DESIGNER:
Shawn Murenbeeld

ILLUSTRATOR:
Shawn Murenbeeld

PHOTOGRAPHER:
Hill Peppard

COPYWRITER:
Leslie Ehm

RIGHT: On all of the main divider pages, the header type and the various icon designs are positioned in a consistent arrangement. While maintaining a similar overall shape, angle, and flow, the position of the other elements varies slightly within the horizontal format.

BELOW: Inspired by the look of an old 1940s trade catalog, the modular brochure consists of geometric shapes with rounded corners, which flow from page to page. Each product section has a unique four-column grid that varies. The spreads are slightly different, but maintain their cohesiveness. Having a larger grid system in place provides great flexibility and the opportunity to move and alter elements within the space.

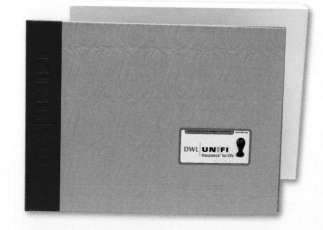

LEFT: The customized three-ring binder is adorned with cloth and book tape and is debossed with an overall pattern that is reminiscent of the corporate head icon. The cover, simple and subtle, is quite flexible. Several color-coded stickers have been designed to label the brochure to meet the needs of the sales staff. To ensure proper positioning, an area has been debossed for the appropriate sticker. Inside, the end papers have been letterpress-printed with a variation of the same icon pattern. The brochure is housed inside a white paper box.

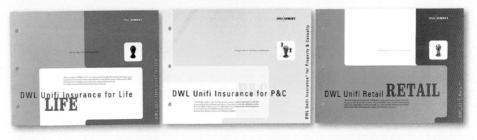

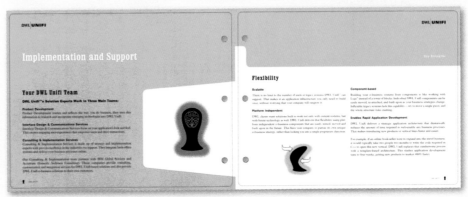

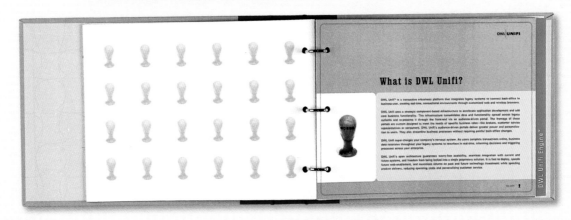

CLIENT:
The Turner Foundation is committed to the preservation of the water, air, and land.

FIRM:
EAI

CREATIVE DIRECTOR:
David Cannon

DESIGNER:
Courtney Garvin

ILLUSTRATOR:
Courtney Garvin

COPYWRITER:
Bruce Barcott

ABOVE: On the cover of the annual report, a pie icon is used to convey the four key messages—*seemingly improbable, radically simple, undeniably possible,* and *quietly bold.* The wraparound jacket also serves as a poster, stating the beliefs of the foundation. On the back of the poster is a full listing of all of the grantees.

LEFT: Throughout the annual report, the pie icon is reconfigured to tell the story of the foundation and to relay each key message. The report is printed with earth-tone colors on tree-free paper made of hemp and sugar cane. The pie acts as a template, which is enlarged, reduced, and repeated to create harmony and continuity throughout.

LEFT: Throughout the annual report, the pie icon is reconfigured to tell the story of the foundation and to relay each key message. The report is printed with earth-tone colors on tree-free paper made of hemp and sugar cane. The pie acts as a template, which is enlarged, reduced, and repeated to create harmony and continuity throughout.

Directory of Designers

Aegis Toronto
672 Dupont Street, Suite 402
Toronto, ON M6G 1Z6
Canada
phone: (416) 364-2144
fax: (416) 364-8841
www.ideaschangereality.com
gsalmela@ideaschangereality.com

After Hours Creative
5444 East Washington, Suite 3
Phoenix, AZ 85034
phone: (602) 275-5200
fax: (602) 275-5700
www.ahcreative.com
russ@ahcreative.com

Anne Telford
3661 Folsom Street
San Francisco, CA 94110
phone: (650) 815-4222
fax: (650) 326-1648
annet@commarts.com

Belyea
1809 Seventh Avenue, Suite 1250
Seattle, WA 98101
phone: (206) 682-4895
fax: (206) 623-8912
www.belyea.com
patricia@belyea.com

Blackletter Design
606 Meredith Road, NE #4
Calgary, AB T2E 5A8
Canada
phone: (403) 209-6112
fax: (403) 209-6113
bessiek@cadvision.com

BBK Studio
648 Monroe Avenue NW, Suite 212
Grand Rapids, MI 49503
phone: (616) 459-4444
fax: (616) 459-4477
www.bbkstudio.com
yang@bbkstudio.com

Cahan & Associates
171 Second Street, 5th Floor
San Francisco, CA 94105
phone: (415) 621-0915
fax: (415) 621-7642
www.cahanassociates.com
Shannonhw@cahanassociates.com

Cathie Bleck
2270 Chatfield Drive
Cleveland Heights, OH 44106
phone: (216) 932-4910
fax: (216) 932-4616
www.cathiebleck.com
cb@cathiebleck.com

Diefenbach Elkins Davis Baron
6 Northburgh Street
London, EC1V 0AY
UK
phone: +44 207 437 9070
fax: +44 207 734 0291
www.futurebrand.com
info@futurebrand.com

Doppio Design
Studio 7
13-15 Smail Street
Ultimo, NSW 2007
Australia
phone: +61 2 9212 0405
fax: +61 2 9280 2457
www.doppiodesign.com
studio@doppiodesign.com

DWL Incorporated
230 Richmond Street East, Level 2
Toronto, ON M5A 1P4
Canada
phone: (416) 364-2045
fax: (416) 364-2422
www.dwl.com
smurenbeeld@dwl.com

EAI
887 West Marietta Street, Suite J-101
Atlanta, GA 30318
phone: (404) 875-8225
fax: (404) 875-4402
www.eai-atl.com
d_gahan@eai-atl.com

Emery Vincent Design
Level 1, 15 Foster Street
Surry Hills, NSW 2010
Australia
phone: +61 2 9280 4233
fax: +61 2 9280 4266
www.emeryvincentdesign.com
info@emeryvincentdesign.com

Hally O'Toole Design
244 West 300 N, #105
Salt Lake City, UT 84103-1145
phone: (801) 355-5510
www.hallyotoole.com

Hornall Anderson Design Works
1008 Western Avenue, Suite 600
Seattle, WA 98104
phone: (206) 467-5800
fax: (206) 467-6411
www.hadw.com
info@hadw.com

Jason & Jason Visual Communications
11B Box 2432
Raanana, 43663
Israel
phone: +972 9 7444282
fax: +972 9 7444292
www.jandj.co.il
tamar@jandj.co.il

Jennifer Sterling Design
PO Box 475428
San Francisco, CA 94147-5428
phone: (415) 621-3481
www.sterlingdesign.com
marketing@jsterlingdesign.com

Joel Nakamura Paintings & Illustrations
72 Bobcat Trail
Santa Fe, NM 87505
phone: (505) 989-1404
fax: (505) 989-7448
www.joelnakamura.com
joel@joelnakamura.com

Kirsten Schultz Design
4 Milk Street
Portland, ME 04101
phone: (207) 871-1198
fax: (207) 879-5959
kschultz@maine.rr.com

Lewis Moberly
33 Gresse Street
London, W1T 1QU
UK
phone: +44 20 7580 9252
fax: +44 20 7255 1671
www.lewismoberly.com
hello@lewismoberly.com

Magma
Bachstrasse 43
D-76185 Karlsruhe
Germany
phone: +49 721 929 19 70
fax: +49 721 929 19 80
www.magma-ka.com
harmsen@magma-ka.de

Michael Osborne Design
444 De Haro Street, Suite 207
San Francisco, CA 94107
phone: (415) 255-0125
fax: (415) 255-1312
www.modsf.com
mo@modsf.com

Miriello Grafico
419 West G Street
San Diego, CA 92101
phone: (619) 234-1124
fax: (619) 234-1960
www.miriellografico.com
pronto@miriellografico.com

Murphy Design Inc.
1240 Golden Gate Drive
San Diego, CA 92116
phone: (800) 486-6275
www.murphydesign.com
Murphy@murphydesign.com

Ove Design & Communications
164 Merton Street
Toronto, ON M4S 3A8
Canada
phone: (416) 423-6228
fax: (416) 423-2940
www.ovedesign.com
start@ovedesign.com

Plainspoke
18 Sheafe Street
Portsmouth, NH 03801
phone: (603) 433-5969
fax: (603) 433-1587
www.plainspoke.com
matt@plainspoke.com

R2 Design
Praceta D Nuno Alvares
4450 Matosinhos
Pereira 20 5 FQ
Portugal
phone: +351 22 938 68 65
fax: +351 22 938 94 82
liza@rdois.com
www.rdois.com

Redpath
5 Gayfield Square
Edinburgh EH1 3NW
UK
phone: +44 131 556 9115
fax: +44 131 556 9116
www.redpath.co.uk
redpath@redpath.co.uk

Reebok
1895 J.W. Foster Boulevard
Canton, MA 02021
phone: (781) 401-5000
fax: (781) 401-4077
www.reebok.com
eleni.chronopoulos@reebok.com

Renee Rech Graphic Design
230 West Tazewell Street, Suite 309
Norfolk, VA 23510
phone: (757) 622-3334
fax: (757) 622-2274
renee@reneerechdesign.com
www.reneerechdesign.com

Reservoir
141 Beaver Street
San Francisco, CA 94114
phone: (415) 558-9605
fax: (415) 558-8248
www.reservoir-sf.com
postmaster@reservoir-sf.com

Rick Sealock Illustration
391 Regal Park NE
Calgary, AB T2E 0S6
Canada
phone: (403) 276-5428
fax: (403) 276-5428
www.ricksealock.com
sealock@telusplanet.net

SamataMason Inc.
101 South First Street
Des Plaines, IL 60016
phone: (847) 428-8600
fax: (847) 428-5664
www.samatamason.com
susan@samatamason.com

SJI Associates Inc.
1001 6th Avenue, 23rd floor
New York, NY 10018
phone: (212) 391-7770
fax: (212) 391-1717
www.sjiassociates.com
suzy@sjiassoaciates.com

Skidmore Inc.
29580 Northwestern Highway
Southfield, MI 48034-1031
phone: (248) 353-7722
fax: (248) 353-1199
www.skidart.com
Julie@skidart.com

Soapbox Design Communications
1055 Yonge Street, #209
Toronto, ON M4W 2L2
Canada
phone: (416) 920-2099
fax: (416) 920-8178
www.soapboxdesign.com
gary@soapboxdesign.com

Stan Gellman Graphic Design, Inc.
4509 Laclede Avenue
St. Louis, Missouri 63108
phone: (314) 361-7676
fax: (314) 361-8645
www.sggdesign.com
barry@sggdesign.com

Starshot
Bachstrasse 43
D-76185 Karlsruhe
Germany
phone: +49 721 92919 74
fax: +49 721 92919 80
www.starshot.de
harmsen@starshot.de

Stoltze Design
49 Melcher Street, 4th Floor
Boston, MA 02210
phone: (617) 350-7109
fax: (617) 482-1171
www.stoltzedesign.com
christine@stoltzedesign.com

Summa
Roger de Lluria 124
Planta 8
08037 Barcelona
Spain
phone: +34 93 208 1090
fax: +34 93 459 1816
www.summa.es
wmarnich@summa.es

SVP Partners
15 Cannon Road
Wilton, CT 06897
phone: (203) 761-0397
fax: (203) 761-0482
www.svppartners.com
rls@svppartners.com

Thumbnail Creative Group
403–611 Alexander Street
Vancouver, BC V6A 1E1
Canada
phone: (604) 736-2133
fax : (604) 736-5414
www.thumbnailcreative.com
rik@thumbnailcreative.com

Viva Dolan
99 Crown's Lane
Toronto, ON M5R 3P4
Canada
phone: (416) 923-6355
fax: (416) 923-8136
www.vivadolan.com
info@vivadolan.com

WYSIWYG Communications Private Limited
Mews 3 Tivoli Court
Calcutta 700019
India
phone: +280 2154/3628
fax: +287 2561
www.wysiwyg.co.in
wysiwyg@vsnl.com

About the Author

Lisa L. Cyr is a writer, designer/illustrator, and national lecturer. Her clients include advertising agencies, corporations, and publishers. She speaks actively about successful promotional strategies, marketing opportunities, and entrepreneurial endeavors for designers and illustrators at universities, professional organizations, and industry conferences across the country. In addition to her speaking engagements, Cyr writes for many of the industry trade publications including *Communication Arts*, *Step-by-Step Graphics*, *HOW*, *International Design*, and *Applied Arts* to name a few. Her articles range from revealing issues that face the industry to featuring top talent in the design and illustration business. A graduate from The Massachusetts College of Art (BFA) and Syracuse University (MA), Cyr's creative work has been exhibited both nationally and internationally. Her work is also in the permanent collection of the Society of Illustrators' Museum of American Illustration. Cyr is an artist member of the Society of Illustrators, NYC and the Illustrators Partnership of America. She works in partnership with her husband, Christopher Short, graphic designer and animator.